# One Wedding

## How to Photograph a Wedding from Start to Finish

**Brett Florens**

AMHERST MEDIA, INC. ■ BUFFALO, NY

Photograph by Samantha Lauren.

**Brett Florens** launched his career as a photojournalist in 1992, while fulfilling national service obligations in his native South Africa. Since then, his devotion to photography has taken Brett from covering police riot squads to a highly successful career as a wedding, commercial, and fashion photographer—with long-standing clients such as Wonderbra, Playtex, Quiksilver, and Roxy. Recently, he received the distinction of being chosen as the representative Nikon Wedding Photographer, making him one of twelve photographers chosen worldwide as the best in their particular field. Brett is also the author of *Brett Florens' Guide to Photographing Weddings* and *Modern Bridal Photography* (Amherst Media®). He currently travels extensively, shooting and hosting professional seminars. Visit www.brettflorens.com for more information on Brett or to check out the video companion to this book (enter code WUE-FLY-BQC-XVE-PAP at checkout for a 50 percent discount).

Published by:
Amherst Media, Inc.
P.O. Box 586
Buffalo, N.Y. 14226
Fax: 716-874-4508
www.AmherstMedia.com

Publisher: Craig Alesse
Senior Editor/Production Manager: Michelle Perkins
Associate Editor: Barbara A. Lynch-Johnt
Associate Publisher: Kate Neaverth
Editorial Assistance from: Carey A. Miller, Sally Jarzab, John S. Loder
Business Manager: Adam Richards
Warehouse and Fulfillment Manager: Roger Singo

ISBN-13: 978-1-60895-695-1
Library of Congress Control Number: 2013952492
Printed in the United States of America.
10 9 8 7 6 5 4 3 2 1

**Check out Amherst Media's blogs at:** http://portrait-photographer.blogspot.com/
http://weddingphotographer-amherstmedia.blogspot.com/

# Contents

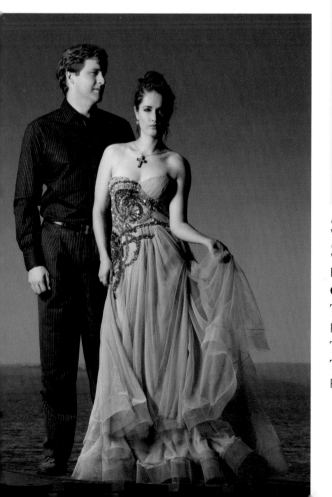

# 4. Pre-Ceremony Images ........................... 36

# 5. At the Church ............ 64

# 6. Time to Celebrate....... 91

# The Journey

Every wedding is a journey. It starts off slowly, many months before the "big day," then begins to accelerate as the auspicious occasion draws closer. All along the road, frenetic activity, unforeseen challenges, and heightened emotions cause bumps and swerves. When the day dawns, the hill to climb in the hours ahead can seem arduous—or, for the über-prepared and relaxed, it can be smooth sailing. Once the formalities are over and the party gets started, it's usually a happy downhill ride to the end of the day!

**P-1.** Meet Claire and Chris. They're an engaged couple, and we're going to be following them throughout the course of their photography—before, during, and after the wedding. We'll also look at the albums that were created for them.

**P-2, P-3, P-4.** From the engagement session, to the wedding ceremony, to the reception (and beyond!), we'll look at how images were created for Claire and Chris.

As professional wedding photographers, we are there to make this journey as pleasant as possible for our clients. With our guidance, the process can be completely enjoyable and memorable for everyone involved.

*"One Wedding* will clearly explain how I planned and executed each phase of the shooting."

In this book, I'm going to take you step by step through an entire wedding, showing you how to smooth the road for your clients. I invite you to follow me through the process, from the pre-shoot production procedures (engaging with the client about the look and feel of the shoot, developing and researching mood boards), to the engagement shoot, all the way through the wedding day, and on to a post-wedding shoot. We'll even look at how the shooting and album-design processes go hand in hand to produce the couple's perfect engagement and wedding albums.

*One Wedding* will explain how I planned and executed each phase of the shooting. I will take you through equipment choices and explain the technical elements that go into creating perfect products for my clients. Marketing is essential when trying to attract a specific client, so I'll also be sharing techniques to help attract and secure your target market, allowing you carte blanche to create images and storybooks that reflect your vision and unique interpretation of the event.

# Deciding
# What to Shoot

## It Starts with the Engagement Session

After your initial meeting with your client (where they secure your services, contracts are signed, and terms and conditions are discussed), you will need to set up a meeting to discuss the engagement shoot. This shoot is usually scheduled six to eight months before the wedding and has a few very clear advantages. First, it allows you to get to know your client better and helps them get accustomed to your manner of working with people. Additionally, it is a great opportunity to explore different facets of their personali-

**1-1.** During the engagement session, you and the clients can get to know each other.

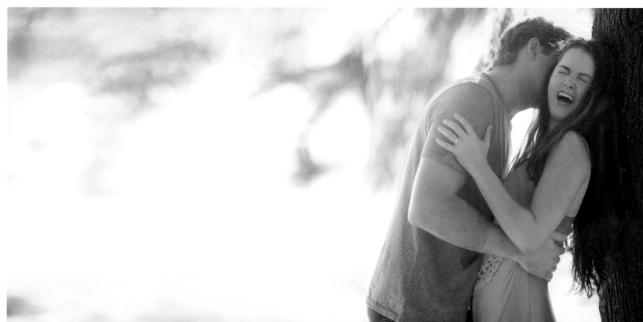

# Research Your Clients

Deciding on the theme and style of the engagement shoot can be a very enjoyable exercise. It liberates you to create images that you like and that are representative of your brand. When brainstorming about the look and feel of the shoot, I try to get to know my clients as much as possible.

Social media is a useful tool for gathering information, giving us some insight into clients' likes, dislikes, and personalities. I ask to become a "friend" or contact with my clients on Facebook or any other social media site they use. Then, I look at which television shows, movies, books, music, and clothing brands they like. This gives me some parameters to work within when developing a theme and style for their session. Based on this data, I have a pretty good idea that the client is going to like what I present to them.

On researching Claire and Chris, I found that they enjoy the outdoor life and that Claire has a particular equestrian affection. They both enjoy waterskiing and are quite active. Travel is high up on their agenda, and they enjoy visiting great restaurants in wonderful destinations. Each of them has an effortless sense of luxury about them and they enjoy

*I also looked through the couple's images to see how they reacted to being in front of the camera.*

fashion. They look just as comfortable in jeans and t-shirts, lounging around on a lazy Sunday afternoon, as they do in designer brands at the most elegant of restaurants in a glamorous city.

I also looked through the couple's images to see how they reacted to being in front of the camera. I noticed that, while Claire was quite extroverted, Chris was more reserved with a confident strength about him.

ties by shooting images that reflect not only their individual styles but also their identity as a couple. It is during this session (and day-after session; see chapter 7) that you have the greatest poetic license to design creative images for the couple.

## Developing the Themes

I usually shoot three themes for each engagement session. My objective is to create about twenty double-page spreads for the storybook, incorporating perhaps fifty images.

Three setups can, with careful preparation, be shot in a half day, which is a comfortable duration for the session. If it takes less time, the client might not feel as if they were getting a good value. If the shoot lasts much longer, the client can feel that things have become too drawn out and laborious. In this case, deciding on the three themes for

the engagement shoot was quite easy, because I had fully researched my clients.

**Theme 1: Free-Spirited Bohemian.** I decided to go for a bohemian-inspired, free-spirited look for the first session, using only natural light. I did some research to find images that would convey this relaxed, easy-going side of their relationship. Images that are backlit exude romance, so I collected a set of images to use in a mood board that reflected my ideas for the first chapter of the engagement shoot. Visual concepts can be lost in translation when verbally articulated, so using a mood board lets me visually express my idea to the client in a clear and distinct way.

**Theme 2: Spring-Break Camping Trip Meets *Out of Africa*.** The second part of the shoot would incorporate their love for the outdoors and was inspired by Tommy Hilfiger and Polo advertisements in magazines such as *Vogue* and *Harper's Bazaar*. A spring-break camping trip meets *Out of Africa* was the look I was aiming for. Again, I researched on the web and created a mood board to convey the concept.

**Theme 3: Luxury and Fashion.** The third chapter I planned to shoot would be a fashion-inspired theme, using designer gowns and lit with powerful portable strobes to create images similar to those in Versace

**1-2.** A mood board with inspiration images for the Bohemian theme.

**1-3.** A mood board with inspiration images for the spring-break theme.

**1-5.** A mood board with inspiration images for the luxury/fashion theme.

ads. Once again, I did my research for poses and lighting to create a mood board that reflected these ideas.

**Progressive Concepts.** I decided to tie all three ideas together by paralleling the growth of their relationship with maturing photographic lighting techniques. I used ambient light for the first theme. For the second theme, I balanced the available light with the Elinchrom Ranger RX and an Octa softbox. For the third theme, I used the Elinchrom Ranger RX with a beauty dish as the primary light source, underexposing the ambient light for a surreal, heavily flashed look.

## PRO TIP > Pitch Your Ideas

Having researched Claire and Chris, I arranged a meeting to discuss my ideas for the shoot. I feel strongly that, as the photographer, you should show the initiative in presenting options to your clients. Asking them what they would like to do for the shoot can put many people way out of their comfort zone. Presumably, your clients have less photographic knowledge than you do, so it seems naïve to assume that they would be able to create and plan the shoot. That is what you are being employed to do.

When presenting my ideas and mood boards to the client, I like to meet up at a great coffee shop or restaurant where I know they will feel comfortable. I find that putting people in their comfort zone makes them more receptive to creative ideas. Chat about how you have researched them and have designed the shoot around your interpretation of their personalities.

In this case, I showed Claire images of herself from Facebook where I felt she looked particularly good or comfortable and explained how these poses could easily be incorporated into the engagement session. When showing the couple the mood boards, I always explain that the images are inspirational guides, not necessarily to be imitated exactly. This gives me some latitude to move outside of the parameters of the inspiration and re-make the looks in my own style.

At this point, I encourage the couple to share their reactions and any desired adaptations to the proposed ideas. Happily, I had done my research perfectly and Claire loved all three concepts. She was very excited about the shoot.

*As the photographer, you should show the initiative in presenting options to your clients.*

We discussed the date and time of the shoot as well as logistical implications, such as hair and makeup as well as wardrobe and props. I let her keep the mood boards so she could share them with Chris and "sell him" on the ideas.

A few hours of research, together with the accumulation of ideas and images, goes a long way in conveying to the bride and groom that you are serious about creating products that are custom-made interpretations of their relationship and wedding celebrations.

I shot the themes in that specific order for two reasons:

1. **Increasing Complexity of Styling.** The progressive angle made the hair and makeup much less time-consuming for the stylists. They started off with a natural look and progressed gradually to heavier makeup and hair.

2. **Boosting the Clients' Confidence.** My clients weren't professional models. Starting off with very unintimidating lighting and posing helped ease them into the shoot and build their confidence. As the morning progressed, I was able to implement more advanced lighting and posing as their confidence in themselves (and in me) grew.

## Styling and Preparing for the Shoot

Because this was a fashion-inspired shoot that had specific wardrobe guidelines, I approached two of our top local designers and asked to borrow garments in exchange for images from the shoot (shots they could use in their marketing). As I had established relationships with them, they didn't need too much persuasion. If you don't know any designers in your area, approach the local college of fashion. You should find some young designers who would love the opportunity to have professional images shot of their garments. You could also ask an up-and-coming or even established stylist to help you out in return for images.

The sourcing for other props and elements took a similar path. I approached the owner of a luggage store for some gorgeous leather luggage that was very representative of the second scene. We borrowed a tent from the local Boy Scouts, and so on. The more mutually beneficial you make the shoot, the more suppliers will be willing to contribute—and not only to the project at hand but often to future projects as well.

> "I encourage the couple to share their reactions and any desired adaptations to the ideas."

It does seem like a bit of an effort, but the images created and the fun we had in setting up the shoot were very rewarding. Additionally, Claire had a great wardrobe to choose from and was very enthusiastic about participating in the whole process, so all the prep work actually enhanced the experience for the client as well.

CHAPTER 2

# The Engagement Session

<span>5:00AM</span> **Travel, Setup, and Scouting**

The shoot was to take place on Claire's family farm, which is a 90-minute drive from my home. To catch the early morning light, we had to leave home at 5:00AM to be ready to shoot at around 7:00AM/7:15AM. We arrived at the farm at 6:30AM, and Andrea (my wife and a professional makeup artist) quickly got to work on the hair and makeup.

In the meantime, my assistant Samantha and I went looking for locations to shoot. We found a nice open field with the early morning sun just coming up over the trees. My essential needs for the opening story, which is all about simplicity, were great light and a nice, clean background.

With natural makeup and a loose hairstyle, we dressed Claire in a Terrence Bray "Indie" crochet dress that was perfect for the light and color of the grass in the field. Chris wore jeans and a simple long-sleeved beige sweater that was great for the casual look.

They made their way down to the field, where I had the mood boards with me as reference. We quickly had a look at the boards to get Claire and Chris into the zone.

<span>7:20AM</span> **Shooting Theme 1**

In general, and I use that phrase cautiously, the men are not as enthusiastic about the session as the women. They tend to be bit more wary of the shoot or withdrawn at the start. Therefore, I tend to start off my engagement

sessions with individual images of the woman. Watching how I shoot and interact with her lets the guy see that the process isn't intimidating. By the time we photograph him, he's relaxed and ready for some great couple shots. At this point, I am just looking for a few simple images without any complicated posing or anything that would be too much out of the subject's comfort zone.

**Camera Settings.** For this session, I shot with a Nikkor 85mm f/1.4 lens at f/2.8 with my Nikon D4 set to aperture priority because I wanted to control the depth of field. For the individual portraits, I chose f/2.8 because I didn't want the background to go too soft and I wanted to make sure that the garments were sharp. I switched to f/4 when photographing the couple to ensure sharpness on both subjects. Since I was shooting in aperture priority, I set my ISO to 400

> "I tend to start off my engagement sessions with individual images of the woman."

to ensure that the camera didn't choose a shutter speed below $^1/_{125}$ second. On the D4, I knew there wouldn't be any grain in the image at this setting. I then fired off a test shot to ensure I had the correct exposure.

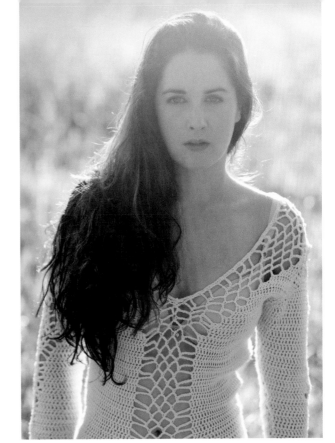

**2-1.** I began with Claire posed square to the camera.

**Portraits of Claire.** We began with Claire standing with her back to the sun to create that romantic, bohemian look. Because there was very strong backlighting and I was not using a reflector to manipulate the ambient light, I needed to compensate with exposure compensation. I checked my histogram and decided to increase the exposure by $+^1/_3$ stop, which looked just right.

I started off by shooting an image of Claire with her body square to the camera (2-1). I had her drop one shoulder to add a little shape to her figure. Articulating the

**2-2, 2-3.** Simple posing variations give me lots of choices when compiling the storybook.

subject is very important to me, and I'm careful to provide just enough direction to get the shots I want. If the subject is very confident and moves well between frames, I tend to direct them less and shoot what unfolds. More often, I am working with clients who aren't experienced models, so I find that some affirmation and direction helps them to relax and enjoy the experience.

> "Some affirmation and direction helps them to relax and enjoy the experience."

Once I had a few versions of the square-on shot—different facial expressions, looking away from the camera, or looking down to the ground—I moved ahead with some

simple variations designed to give me a range of choices when compiling the engagement storybook (we'll see that in chapter 3). I varied the shots not only in terms of facial expressions and posing but also in regard to cropping, shooting wider and closer so I had plenty to choose from (2-2, 2-3). Once I had a shot, I moved on to the next variation. Shooting off hundreds of frames of the same image not only takes up memory space, it also suggests to your subject that either you or they are not getting it right. That will reduce the amount of confidence they have in you or themselves.

I am often asked if I show the images to the client while I'm shooting. I do, but only if I feel that it will benefit the shoot. If you feel that your subject is a little uneasy or self-

conscious, then show them some great images to boost their self-esteem. Letting them preview a few images can also give you an indication of how much they like what you are shooting, which could guide you in the right direction.

**Getting Chris Involved: Couple Portraits.** My next step was to get Chris involved, but I didn't want to make him feel in any way uncomfortable or uneasy, so I started by photographing the two of them together, knowing that being with Claire would probably make him feel a little more secure. (I didn't know for sure that he was uneasy, but this approach eliminated any risk.)

At this stage, I changed my aperture setting to f/4 because I wanted just a little more depth of field. There were now two of them and their eyes were not going to be at the same distance from me all the time, but I needed them *both* to be sharp.

Again, I used some simple poses in the same lighting for continuity (2-4, 2-5, 2-6). Shooting to give myself options, I got them to kiss, look away, look down, etc. I also kept in

> "Letting them preview a few images can give you an indication of how much they like what you are shooting."

**2-4, 2-5, 2-6.** Showing the ring emphasizes that this is an *engagement* portrait. It also gives the image a potential secondary usage in advertising for the jeweler.

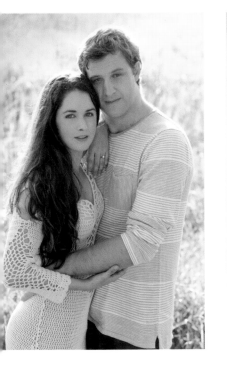
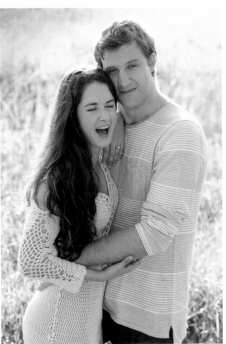
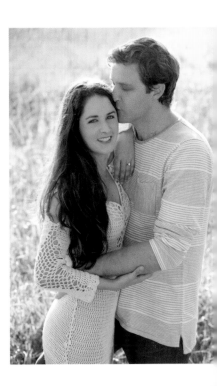

**2-7, 2-8, 2-9.** I created images of Chris that coordinated with the previous images of Claire.

mind supplying other vendors with images. For example, notice that the engagement ring is prominent. It's not a close-up of the ring, but the jeweller might like this image for their marketing or advertising. Also, we mustn't forget the purpose of the shoot: to celebrate their engagement. Showing the ring just makes sense.

**Portraits of Chris.** At this point, we were just about ten minutes into the shoot and I felt that Chris was ready to be photographed on his own. He was as relaxed in front of the camera as he was going to be. I changed my aperture back to f/2.8—for the same reasons as when I was shooting Claire on her own and for continuity. Working with Chris, I created the same number and types of images with him (2-7, 2-8, 2-9) as I had just done with Claire.

Once I had exactly what I wanted from the individual images of Chris, I decided that I wanted a little more variety and movement from him. I had him walk toward me, composing the image as a full-length landscape shot. I shot this

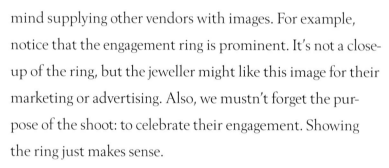

"We were just about ten minutes into the shoot and I felt that Chris was ready to be photographed on his own."

image at f/1.4 to separate him from the background. The field didn't go too soft, though, because I was shooting full length and the greater distance between me and my subject diminished the effect of the shallow depth of field.

As he walked toward me, I had him look at the camera but also look around the area, giving me lots of options (2-10). That worked out well—and I could see the first part of the story coming together nicely. I also noticed that Chris was in good spirits and enjoying the experience. Being aware of your client's state of mind is very important; you need to

work at extracting the best from them to create images they never expected.

**Portraits of Claire, Part 2.** I needed some nice full-length images of Claire to go with the images I created with Chris, so I got Claire back in front of the camera. I started

**2-10.** A full-length landscape image of Chris.

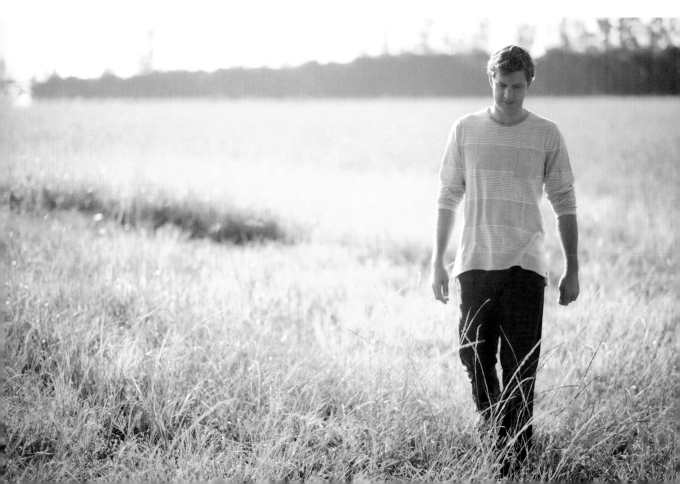

**2-11, 2-12 (RIGHT).** I picked up where I left off with Claire and created some of my favorite looks from the session.

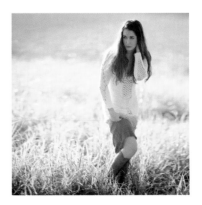

off with a relatively basic pose that was a progression from where we left off. I found that Claire was working well and understood my instructions completely. When my client and I are on the same page it's exciting for me. I get a buzz when I am shooting—especially when I'm creating images that I like and that my clients appreciate.

I asked Claire to move some hair from the side of her face and, as she did that, I saw a pose that I liked (2-11, 2-12). She had her hand in her hair and I asked her to tuck her elbow in, giving her body a great shape. This is one of my favorite shots from the session. To create the look, I shot at f/1.4 but now with only $+^2/_3$ stop exposure compensation because the camera was less influenced by the brightness of the grass.

I shot a few options in that lighting and posing style and then moved to the landscape format, drawing inspiration from a double-exposure type of image I had seen. I had Claire whip her head around, adding even more movement to the shot. As you can see from the framing, I shot from

**2-13 (BELOW).** I shot several images of Claire, knowing I wanted to create a double-exposure effect in postproduction.

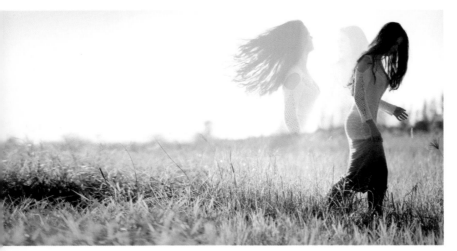

"I shot a few options in that lighting and posing style and then moved to the landscape format . . ."

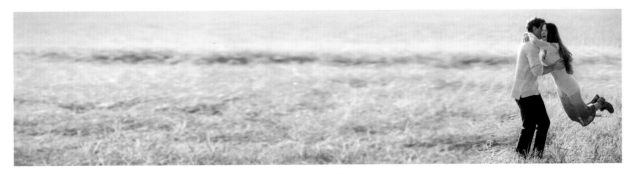

**2-14.** A landscape portrait of the couple, relaxed and totally engaged with each other.

lower down, knowing that (in postproduction) I would need the clean sky to drop in the layers to create the effect I wanted. The inclusion of so much of the lighter sky meant that I had to use an exposure compensation setting of +1 ⅓ stop. I shot quite a few options here, as I knew that I would need several image choices to produce the double-exposure effect I wanted (2-13).

**The Couple, One More Time.** I was very happy with what we had shot so far but felt that I needed a few images of the two of them together with some movement and interaction. These were very simple to shoot. I just had them to walk toward each other and embrace, kiss, or cuddle. I even had Chris swing her around for some movement. By keeping them on the same focal plain, away from me, I was able to catch multiple images without worrying about them being out of focus. I simply locked onto Chris who was stationary during the spin (2-14).

**Wrapping Up Theme 1.** After all the attention, Claire was getting super relaxed, flicking her hair back and forth. I jokingly told Chris not to worry, because I hadn't forgotten about him. After we shot some bonus images of him sitting relaxed on the grass (2-15), the first part of the story was done and the first six spreads of the storybook were neatly laid out in my imagination.

**2-15.** A final image of Chris, sitting in the grass.

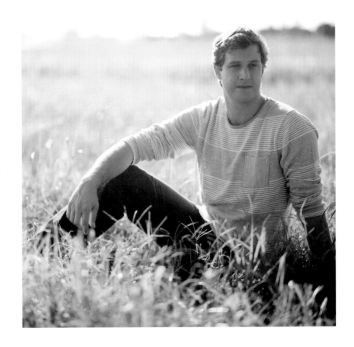

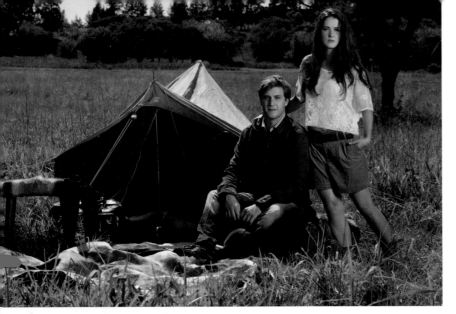

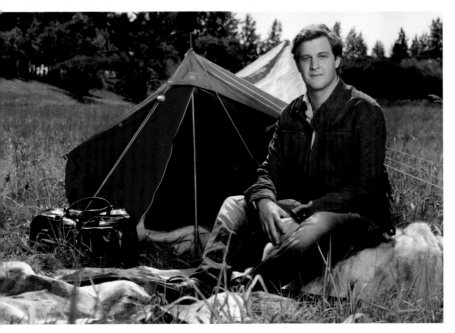

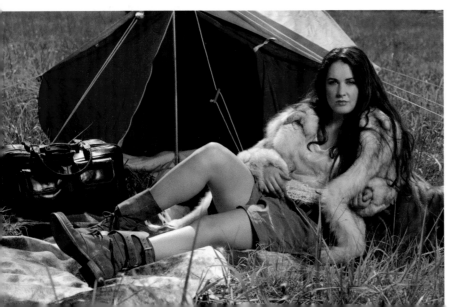

**2-16, 2-17, 2-18, 2-19 (LEFT AND FACING PAGE).** With our borrowed tent and ample props setting the scene, I photographed Chris and Claire individually and as a couple.

## Editorial Style

The roots of editorial photography lie in magazine spreads and fashion shoots. A typical bride will have at least ten magazines in her collection—each marked with stick-it notes on her favorite pages! These magazines have become more and more competitive, and are creating more and more high-fashion shoots to attract brides. Top models are used in these fashion spreads, selling anything from designer dresses to shoes and makeup. The poses are typically high fashion (which is to say they feature body positions that may look even a bit awkward) and the lighting is generally quite dramatic, whether it be very low light, high-contrast, saturated, or heavily backlit. These fashion spreads in the wedding magazines have had a major influence on both photographers and clients, who want to emulate the look and feel of these editorial pages.

## 7:45AM  Setup for Theme 2

Claire went off for a makeup change. Just as I planned for the posing, lighting, and photographic style to increase in complexity/maturity over the course of the three stories, Andrea (our hair and makeup artist) designed Claire's style to evolve over the course of the

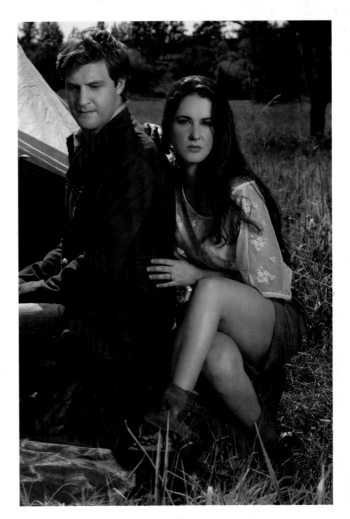

> "The theme embodies a lifestyle of effortless luxury, but there is also a touch of *Out Of Africa* in it."

shoot. As you'll recall, the theme for the next scene was inspired by print advertisements for Ralph Lauren, Polo, and Tommy Hilfiger. The theme embodies a lifestyle of effortless luxury, but there is also a touch of *Out Of Africa* in it. Samantha and I got busy setting up the scene with the sourced props. We had around half an hour to do this, but with a little planning it was easily achieved.

## 8:15AM  Shooting Theme 2

Claire and Chris were now dressed in very stylish garments, incorporating Claire's love for fur and their mutual love of the outdoors—particularly the African savannah. I had Claire's riding boots and helmet in the scene, subtly tying in with the wedding's equestrian theme.

**The First Look.** The poses and expressions for this theme were a lot more confident and had a subtle sexiness to them. As when shooting the previous scene, I wanted plenty of options, so I had them look in different directions. I was constantly thinking about the layout of the album and trying to shoot images that reflected their relationship and their individuality. Shooting the two of them together and separately gives me a lot of variety, adding depth and substance to the storybook (2-16, 2-17, 2-18, 2-19).

**The Second Look.** While shooting Claire on her own, I asked Chris to change into something a little more fun and preppie— again, increasing the options. While shooting Chris on his own, I also had Claire change clothes and Andrea plaited her hair for a different look. I then photographed the two of them together in a more intimate, fun style. The wardrobe and Claire's cute plait added to the "summer vacation" feel of the scene (2-20, 2-21, 2-22).

Both of them were getting into the shoot and loving the experience, which is always

**2-20, 2-21, 2-22.** A styling change for the couple gave the images a different character.

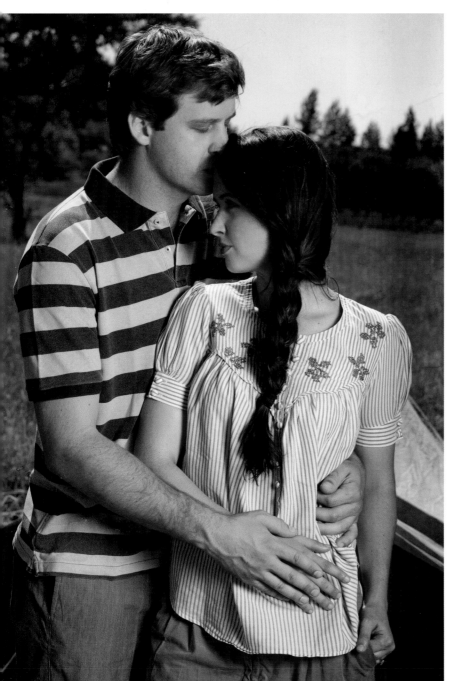

**2-23, 2-24.** Images of Claire in a Francois Vedemme design.

"I used an Elinchrom Octa softbox as my light modifier."

important to me. Creating great images is pointless if the client finds it a laborious or uncomfortable experience.

**Exposure and Lighting.** For all of these images, I shot at $^{1}/_{250}$ second and f/9 at ISO 100. I wanted to balance the foreground with the existing ambient light, so I added an Elinchrom Ranger RX battery-powered strobe and set the flash output to match the ambient light. I used an Elinchrom Octa softbox as my light modifier, giving a soft but powerful feel to the light. This produced a very different look than we saw in the images from the first theme, which were shot purely with ambient light.

### 8:55AM Setup for Theme 3

The last theme was inspired by the heavily flashed images used in Versace's advertising. These images are rich in color, very vibrant, and feature a very surreal gradient effect. Again, Claire and Chris went off to change their outfits. (I had arranged to borrow some gowns from top designers, so I was excited about this scene.) Claire was also due for a further hair and makeup enhancement. In the meantime, Samantha and I headed down to a lake where Claire and Chris often waterski. I wanted to incorporate their love of the lake into the images without making them look cliché in any way. We got busy setting up the lighting while the wardrobe changes were in progress.

### 9:50AM Shooting Theme 3

**The First Look.** Claire arrived wearing a beautiful François Vedemme design, with dramatic evening makeup. I started off by shooting some individual images of her. I wanted

strong, confident poses to match the lighting and editorial feel of the scene and she executed these looks perfectly (2-23, 2-24). These ideas can be very difficult to articulate to clients, but the pre-shoot meeting definitely helps—as does the use of the mood boards as a visual aid. Although photo shoots are very normal for us, they may be out of the ordinary for your subjects—many of whom may never have worked with a professional photographer before. Go easy on them!

As these images were going to be the penultimate look in the storybook, I want to create a smooth transition from the "Polo" look to the final crescendo. I used a beauty dish on the Elinchrom Ranger, giving me strong lines and sharp shadows (2-25, 2-26). This sculptural feel is familiar from fashion/editorial imagery. I set the 1100W strobe to around 80 percent output, which gave me an exposure of $\frac{1}{250}$ second at f/22 and ISO 100. However, I chose a shutter speed ($\frac{1}{160}$ second) that allowed the ambient light to exert a little influence on the image.

**The Second Look.** For the second look, Claire was wearing a stunning Terrence Bray design and Chris was wearing dark trousers with a black shirt. I decided to end with these

**2-25.** I picked up a "Ryan Gosling" vibe from Chris and decided to head in that direction with his individual images.

**2-26.** Chris and Claire together in a dramatic portrait.

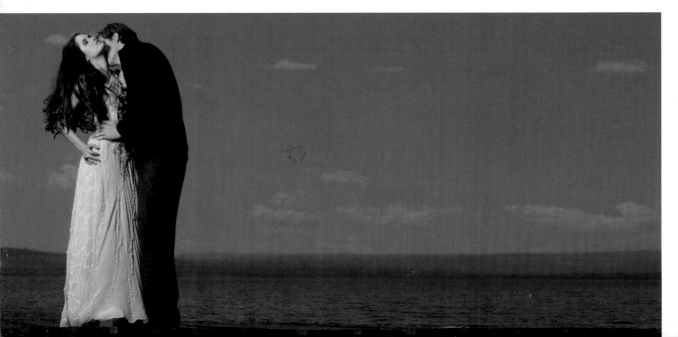

**2-27, 2-28, 2-29.** The final look of the day was the most dramatic and formal of all the setups.

images, because I knew that the lilac and purple tones of the dress were going to work well with the toning I had planned for the images (2-27, 2-28, 2-29). In terms of lighting, I wanted to shoot images that had very little ambient light in them, so I switched my shutter speed to $^1/_{250}$ second. Through a variety of couple and individual poses, the subjects were well lit with the strobe/beauty dish as the primary light source.

### 10:45AM That's a Wrap!

After a fun morning shooting, we packed up our gear and headed back to the farmhouse for some well-deserved refreshments. I was very happy with what we had shot. With careful planning and thought, you can create fantastic images that follow a story line (or some sort of underlying theme) rather than just a string of random images with little or no relevance to each other. This helps keep the viewer interested in the images and more fully reflects the personalities of the couple.

# The Engagement Storybook Design

Each storybook album requires a unique design. I use Adobe InDesign to create custom storybooks for each client. I know that there are many different and effective programs out there for design—but whichever one you decide to use, make sure that the book you deliver has been created especially for that client.

Because I designed the engagement shoot specifically with the storybook layout in mind, the album construction process was quite enjoyable. The album was divided into three

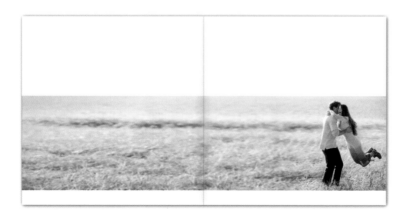

**3-1.** The opening spread in the album.

## Safety First

No matter how you decide to present the images, the very first step in your postproduction should be to back up your files. Download them to your hard drive, then burn a copy or two to DVD and put them in a fireproof safe. This may seem excessive—but let's not even try to imagine the repercussions if all those images were to be lost!

sections, just as the shoot was. In design, threes work well (*omne trium perfectum*— everything that comes in threes is perfect).

## Opening

My opening presentation (3-1) needed to introduce the viewer to the album, but I didn't want to shock them by using a very dramatic image from the last scene. Instead, I wanted a pleasant, happy image with emotion and movement. I created a panoramic image in Photoshop and like the way it introduces us to the album.

## Theme 1

If you look at the total number of images, there is a bias towards the bride. However, I try to have a balanced book that gives both the bride and groom balanced exposure. So starting off with images of the two of them together (3-2) worked well. I presented four different images, in similar poses, on the left-hand side of the spread and then added a larger image that I knew would appeal to both the couple and their families. It is a very safe and expected shot.

The following layout (3-3) featured images of Chris and Claire individually. The design was mirrored for consistency. As you can see, I had both horizontal and vertical

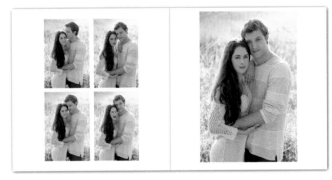

**3-2.** Starting off with images of the couple.

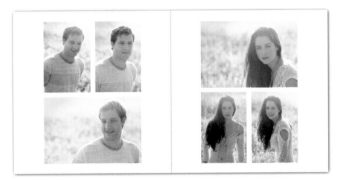

**3-3.** Images of Chris and Claire individually.

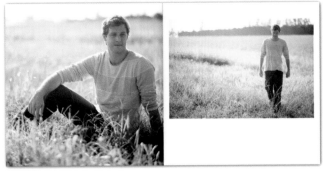

**3-4.** A spread showing Chris alone.

images to choose from, which liberated me to explore some different design options.

Turning to the next page in the album (3-4), the viewer sees Chris in both sitting and standing poses. I like the strength of these images; they emit a feeling of

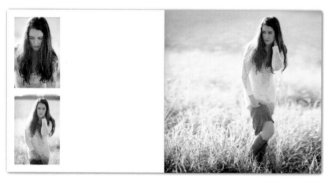

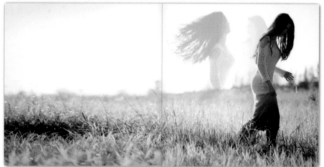

**3-5, 3-6.** Spreads with images of Claire.

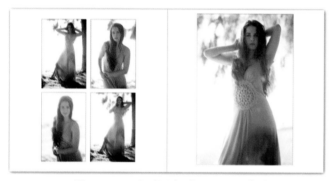

**3-7.** We stay on individual images of Claire, but a change of clothes and different toning effect keep the viewer engaged with the presentation.

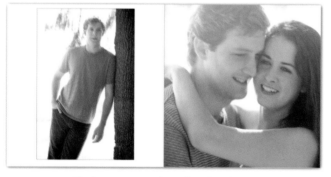

**3-8.** Chris is reintroduced individually, and a tight crop on the couple gives a sense of warmth.

confidence and give us the feeling that he is sure of himself and doesn't mind his own company.

On the next two spreads, I used individual portraits of Claire (3-5, 3-6). I like showing smaller images on a page with negative space around them, followed by an image that fills the page. These images and poses complemented the images of Chris in the previous spread. At this point, we are starting to get some insight into the personalities of the subjects. I love the movement in the second spread. The opaque multiple imagery adds an element of mystery to the bohemian look.

The next layout (3-7) stayed on individual images of Claire, but the change of clothes and toning of the images help hold the viewer's attention without giving the impression that it is all about Claire.

As we turn the page to the next spread (3-8), Chris is reintroduced as an individual subject. The first shot gives the viewer a sense that he was watching Claire's shoot with adoration. The opposite page features a nicely cropped intimate portrait, which fills the page. I like the crop as it feels warm and fuzzy.

Turning the page to the ninth spread of the book (3-9), I presented a fun, happy

**3-9.** A happy moment shared between the two.

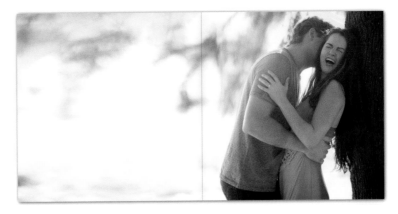

**3-10.** Claire's personality is emphasized.

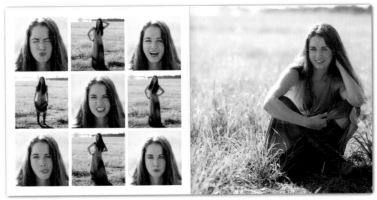

PRO TIP >
## Your Reputation

I advise against offering disc-only services to your clients. Once you hand over the files, you relinquish all quality control. You may advise a client to go to a reputable lab—and the client may have every intention of printing and putting the images into an album. More often than not, however, they simply keep them on their computer or share them on-line. This requires a reduction in size and image quality—and the person viewing the image will then, in all probability, print out the image on an inkjet and frame it for all to see. And what would they see? A badly printed, poor-quality image attributed to *you!*

image of the two of them sharing an intimate moment—you almost want to know what he said to her.

The following two pages (3-10) show us various elements of Claire's personality. I love the fact that she is happy and secure enough to pull funny faces for the camera. In terms of the design, the checkered arrangement of close-ups paired with full-length images worked nicely. The relaxed pose and feeling from the adjacent image complemented the other portraits.

So there we have the first scene complete, ten spreads of the free-spirited "boho" look. I didn't initially anticipate including so many images from that theme, but I don't think that it was too much. I had some great images to work with.

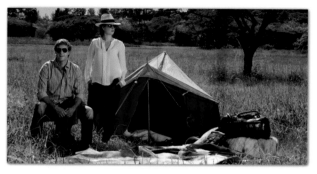

**3-11.** This double-page spread provided a well-defined change from the previous look.

 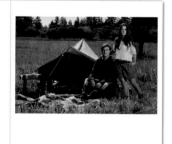

**3-12.** Two different poses with the couple.

 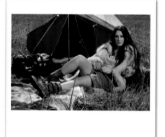

**3-13.** Chris strikes a confident, relaxed pose—while Claire's image is more alluring.

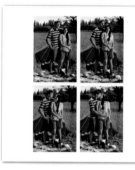 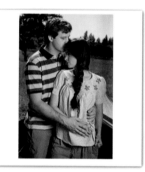

**3-14.** A change of clothes gave these portraits of the couple a more relaxed feel.

## Theme 2

Next, the album moves into the Ralph Lauren/Polo/Tommy Hilfiger meets *Out of Africa* look. I started with a double-page spread (3-11) that is very stylized and posed. I like the visual impact of the shot and it provided a well-defined change from the previous look.

The next layout from this theme (3-12) has Chris wearing his leather jacket and shows the two of them in different poses, offering some variation to the scene. We then move into images of each of them individually (3-13). I like the confident, relaxed pose Chris took—and Claire's image is quite sensual.

The last spread of the scene (3-14) featured the couple in various poses and in more playful clothing—not taking themselves too seriously. There were only four spreads in this series because I didn't want to kill the look. When a setup is very stylized and static, as this one is, showing too many similar images could make the album feel tedious.

## Theme 3

I felt that the transition to the final theme needed to be smoother than the definitive change between themes 1 and 2. I started off with two images of Chris (3-15). Although his look is strong, it isn't as jarring a change as if I had jumped directly from the camp shots to images of Claire in her dramatic makeup and gown. With the scene set, we can move to the next spread (3-16) and more gracefully introduce those individual images of Claire with a stronger demeanor. A double-page spread of the two of them together (3-17) follows, giving us a sense of space and passion.

**3-15.** Individual images of Chris smooth the transition into the third theme.

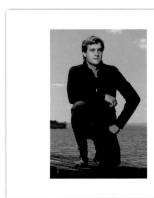

**3-16.** Dramatic images of Claire in a beautiful gown.

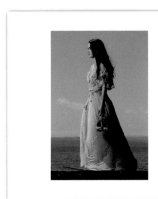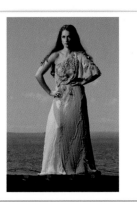

**3-17.** A double-page spread of the couple gives a sense of passion and space.

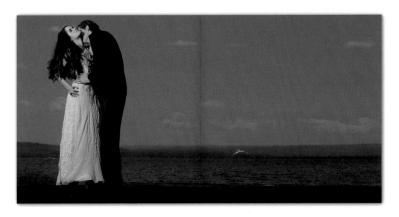

**3-18, 3-19.** Individual images of Chris created in the style of Versace advertisements.

The final section in this series started off with very heavily flashed images of Chris (3-18), with a toning look similar to that used in Versace advertisements. This was followed by a very strong double-page spread of Chris with a determined walk and look (3-19).

PRO TIP >
# Dominant Space

If the location allows for it, you can create a photograph that is highly impactful by placing your subject on a rule-of-thirds line, with a lot of space either around them or in front of them. This will only work if the background is not too busy. A large expanse of sky, a mountain, or a sand dune will have a stunning effect as a backdrop or foreground—and it will serve to tell the story of the location that the couple have chosen as their venue.

**3-20 (TOP).** The feeling of drama and luxury continues with portraits of Claire and the couple together.

**3-21 (BOTTOM).** The album concludes with an image designed to leave a powerful impression.

In the following spread, I showed Claire on her own in another beautiful gown, with an image of the two of them on the opposite page (3-20).

I finished the book with a striking image of the couple in a passionate embrace (3-21). This completed the album with a very strong, appealing image that should leave a great impression.

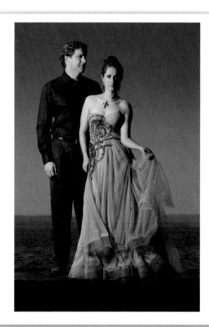

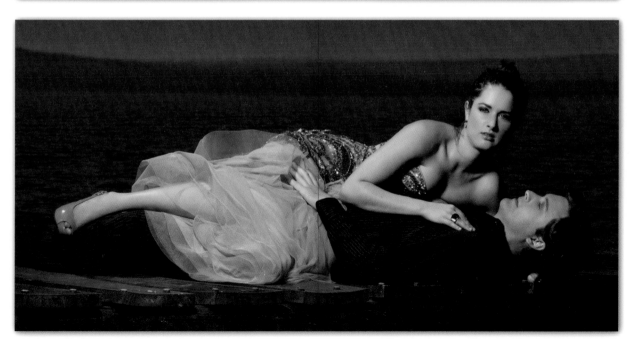

# Pre-Ceremony Images

On the morning of the wedding, I arranged to meet Chris at the beach where he spends a lot of time. I thought this would be a memorable place for him to have photos and I wanted to start the day by shooting the guys. This reduces the amount of time I need to spend with them later on in the day. It also gives the guys something to do in the morning, rather than sitting around getting bored or getting up to no good while waiting to get dressed! (Brides usually thank me for the intervention.)

### 8:05AM | Beach Silhouette

When Chris and his groomsmen arrived at the beach, I immediately took Chris down to the shoreline where I shot a few images of him walking and then jogging at the water's edge (4-1). For a silhouette with a beautiful golden glow in the sunrise, I underexposed by 2 stops. I shot this with my Nikon D4 and the 70–200 f/2.8 lens at f/2.8. My camera was at ISO 50 and $\frac{1}{8000}$ second on aperture priority.

> "When Chris and his groomsmen arrived, I immediately took Chris down to the shoreline."

I wanted to create an image that emitted a sense of calm and peace, something that portrayed Chris contemplating the importance of what lay ahead for him that day. I

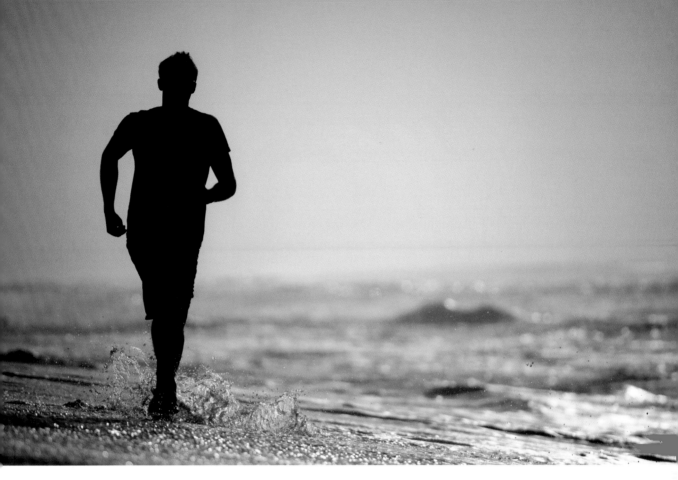

**4-1.** A silhouette of Chris at the beach.

**4-2.** A different look with Chris on the beach.

got down nice and low to give the shot a sense of depth, with soft sand in the foreground and Chris very sharp in the background (4-2). Shooting at f/2.8, I changed from single focus to continual focus (AFC). I also changed my focal point selector to auto, so the camera would detect Chris moving toward me and adjust to keep the point of focus sharply on him.

## 8:20AM Fun With the Guys

After a short time at the water's edge, I took Chris back to the rest of the groomsmen and we started shooting the guys playing a game of touch rugby on the beach.

**Activity-Based Images.** I like to have the guys do something fun, rather than going straight into a daunting formal shoot. Guys are often intimidated by the camera, especially

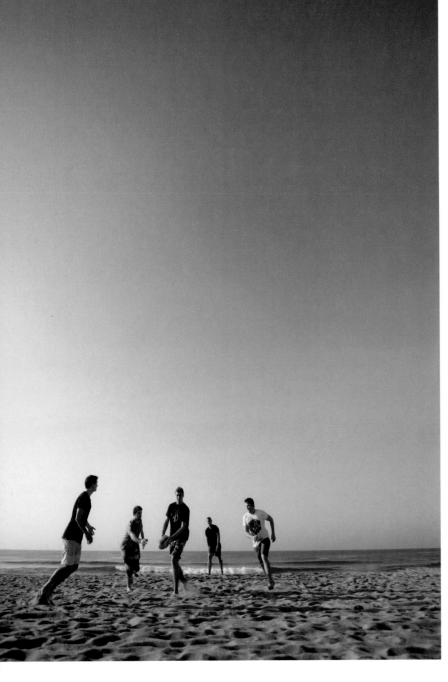

**4-3, 4-4, 4-5.** Getting the guys engaged in a fun activity helps loosen them up.

"Engaging them in something they enjoy gets the guys used to me hanging around with a camera."

when they are with their friends. Engaging them in something they enjoy (be it fly fishing, bowling, or playing soccer) gets them used to me hanging around with a camera (4-3, 4-4, 4-5). As the boys played touch rugby, I continued shooting with the autofocus system that I had used with Chris at the water's edge (AFC and auto focal point select).

**Enhancing the Story.** In the storybook (see chapter 8), these images complement the photographs of the bride and her bridesmaids getting ready—shots where there is

also a lot of frenetic activity. Pairing these images says a lot about the start of the day for the different sexes. The females are swept up in the chaos of fervently beautifying themselves with professional makeup and hair styling, making sure that the flowers have arrived, last-minute alterations to dresses, and the like. The males, on the other hand, have a far easier start to the day. They get to horse around, playing their favorite sport, whiling the time away before they quickly shower, shave, and climb into their suits. The contrasting female and male pictures add a bit of humor to the album.

## PRO TIP > Strong Lighting, Strong Look

Once I completed some action shots and they were more relaxed with me and my camera, we decided to do a posed shot—a sort of spoof image created to make them look like serious sportsmen in a poster promoting rugby for the World Cup or a television advertisement (4-6). To create the right intensity for this image, I needed very strong lighting. I added an external strobe (the Ranger RX), firing it up to very high power (ISO 100 and $\frac{1}{250}$ second at f/18), which gave me a nice dark sky. With flash as the primary light source on Chris and the groomsmen, it really looks as though they are the stars in a poster promoting the sport.

**4-6.** Chris and his groomsmen are the stars of this image.

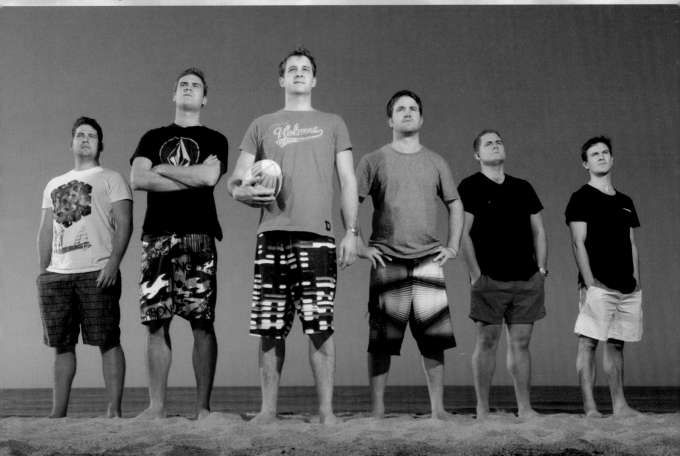

## 8:50AM To the Groom's House

The beach shots of the guys took about 45 minutes. Ten minutes later, we were at the groom's home, where he jumped into the shower. In the meantime, I scouted the house for the ideal spot to take individual shots of Chris. I found a spare room with nice light coming through the windows and net curtains. I knew I could use this for back-lighting to create nicely diffused images. Net curtaining in front of a large window acts like a big softbox behind the subject.

## 9:20AM The Groom Gets Going

I asked Chris to put on his shirt and trousers without buttoning up just yet, then draped his tie over his neck to make it look as though he was in the process of getting dressed (4-7, 4-8, 4-9). I had him stand with his back to the window, then compensated for the extreme contrast in the scene by overexposing to $+\frac{2}{3}$ stop. I shot these images with the 85mm

**4-7, 4-8, 4-9.** *GQ*-style images of Chris backlit by net curtains over a large window.

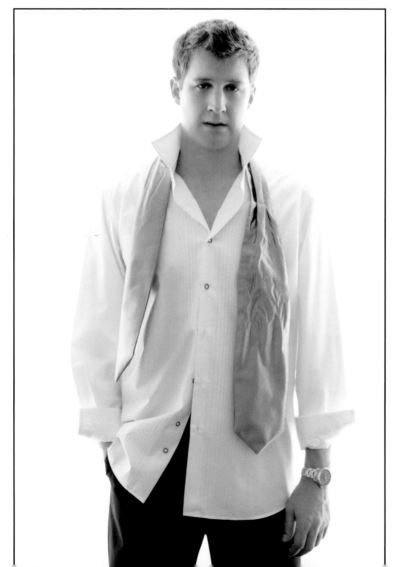

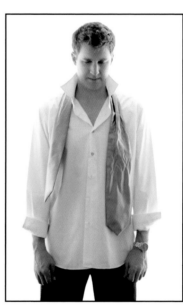

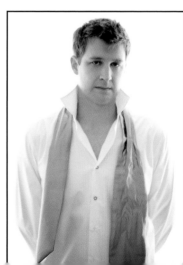

**4-10, 4-11.** Detail images of Chris getting dressed.

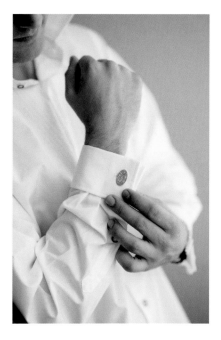

**4-12, 4-13.** Shooting both subdued and smiling expressions assured me I had my bases covered.

f/1.4 lens at f/2, which resulted in the image being shot at $^1/_{500}$ second at ISO 1000. This type of image is very much in the vein of a George Clooney, GQ-style shot with the tie draped over his shoulder and quite a serious look on his face. I planned to use it in the album as a large picture, paired with detail images of him getting dressed. As you can see, I am constantly thinking about the storybook layout. (The design of this album is shown in chapter 8.)

Next, I asked Chris to start buttoning up and stepped in closer to get tight shots of him putting on his cuff links and setting his tie (4-10, 4-11). I then had him turn around so that his back was to the window and he was facing me (4-12, 4-13). In this pose, I covered my bases by getting smiling and serious expressions. For the storybook, I envisioned having a shot of him getting ready on the left side of a spread and then a shot of him with his tie on, completely dressed, on the right-facing page.

**4-14, 4-15, 4-16 (ABOVE).** A shallow depth of field gave these images a magazine-style look.

**4-17, 4-18, 4-19, 4-20 (LEFT).** These safe, simple shots have a classic look with broad appeal.

I then transitioned to images of Chris sitting on a small chair (4-14, 4-15, 4-16). I shot these wide open with the f/1.4 lens (at ISO 400 and $\frac{1}{160}$ second). This super-shallow depth of field, with the eyes very sharp and quite a lot of immediate falloff, made the images look like they belong in a magazine.

> "I used his waistcoat as the background so that I had nice lines leading into the shots."

I overexposed these images by $+\frac{1}{3}$ stop because I wanted his skin to be slightly washed out. This would be in keeping with the desaturated look I planned to use on the complete sequence of "getting ready" images that would form one chapter in the wedding storybook.

## 9:30AM Classic Portraits, Detail Images, and a Found Moment

**Getting the "Safe" Shots.** Next, it was time for some safe shots with more flat lighting— nice, simple portraits that would appeal to his parents. With Chris posed against a wall, I shot four images of him: one smiling, one not smiling, one looking straight into the camera, and one a little tighter (4-17, 4-18, 4-19, 4-20).

They're nice, clean images and I was happy that I pretty much had my safe shots wrapped up at this point. I shot the portraits at f/1.4 and ISO 400 at $\frac{1}{250}$ second.

## PRO TIP > The Groom's Accessories

While Chris went off to do an interview for the videographer, I shot some detail images showing his cologne, watch, cuff links, and tie—anything relevant to the wedding day. I used his waistcoat as the background so that I had nice lines leading into the shots. I knew that I would make a collage of those photos for the storybook (4-21).

**4-21.** A collage of detail images.

# Watch for the Light

As Chris returned, I noticed some nice light along the passage where he was walking (4-22, 4-23). Knowing it would look great, I asked him to pose there, leaning against the wall. In the heavy backlighting, I increased my ISO to 2000 and moved to f/2.8, overexposing to +1⅓ stop. The result was two nice black & white images.

**4-22, 4-23.** I spotted some nice light in this passage and had Chris pause for a couple images.

9:40AM **The Guys On Location**

**Individual Images.** On my way to the house, I spotted an area under a motorway bridge that had a good masculine look. The stark, heavy concrete had a clean but commanding feel to it. I asked all the groomsmen to meet me there for some individual portraits. Not all of these portraits will necessarily go into the album, but having nice shots of each groomsman will generate reprint sales after

> "I made three shots of each groomsman, with small variations."

the wedding. I also keep in mind that I could potentially be photographing a future client, so I make sure to get good pictures of each member of the bridal party. In this case, I made three shots of each groomsman, with small variations (4-24, 4-25, 4-26). As soon as I had photographed all the boys, I took some nice shots of Chris in the same position (4-27, 4-28, 4-29). I shot these portraits on ISO 200 at f/2.8 and $\frac{1}{250}$ second (+1 stop exposure compensation) using the 70–200 f/2.8 lens.

**4-24, 4-25, 4-26.** I photographed three slightly varying images of each groomsman alone.

**4-27, 4-28, 4-29.** Then, I made a similar sequence of images with the groom in the same spot.

**Group Portraits.** Next, it was time for a shot of the guys together. First, I had Chris and his groomsmen pose in a relaxed fashion, leaning up against the wall and chatting with each other (4-30, 4-31). Then I took a more formal shot where Chris was looking into the camera with one hand in his pocket and the others looking at him from behind (4-32). I shot this at ISO 800 on the 70–200 lens at $^{1}/_{500}$ second and f/2.8. I set the exposure compensation to $-1^{2}/_{3}$ stops to correct for the influence of the dark suits on the camera's matrix meter reading.

**4-30, 4-31 (TOP, LEFT AND RIGHT).** Casual images of Chris and his groomsmen.

**4-32 (BOTTOM).** A more formal pose of the guys with Chris brought forward to a more prominent position.

**4-33, 4-34.** The videographer wanted some footage of the guys walking. I took the opportunity to create some still images at the same time.

"I jumped at the opportunity for images with a bit of motion."

**On the Move.** At this stage, the videographer wanted a shot of the guys walking, so I jumped at the opportunity for images with a bit of motion. Again, these are shots I might not use in the album, but it is useful for me to have options (4-33, 4-34). I knew the dark suits would offer great contrast in relation to a bright background, so I used +2 stops exposure compensation, shooting at ISO 800 and f/2.8 at $\frac{1}{320}$ second. I photographed the guys walking all in a row, making the images look like they came from a movie scene or a CD cover. I then moved in for a closer shot of Chris chatting with his groomsmen. That wrapped up the photography of the guys—and the time was 9:50AM.

### 10:00AM A Quick Break

I had put some time aside for a break, so we went off to a coffee shop and enjoyed a toasted sandwich and a coffee before heading off to Claire's house (where we were expected at 11:30AM). I like to build in a buffer like this. Not only is it good to have extra time in case

something goes wrong, but it's good to plan for a break in your day. When photographing a wedding, you are looking at something in the region of a fifteen- or sixteen-hour day, so you need to stop and refuel.

### 11:30AM At the Bride's House

At 11:30AM sharp, I arrived at Claire's home where she was getting ready. I make it a rule not to walk into the bridal preparation room carrying any gear. I know how chaotic this room can be and I don't want to add to the clutter. Additionally, I feel that it can be very intimidating to just step in and start shooting. Instead, I walk in and introduce myself to the bride, bridesmaids, and the mother of the bride, asking how Claire is and inquiring after everyone in general.

### 11:40AM Detail Shots, Location Scouting

For this wedding, the reception was going to be at the same location where Claire was getting ready (her parents' home), so that's where I headed. On my way, I also scouted some locations where I could potentially shoot formals of Claire and her bridesmaids. Walking around the home, I made mental notes of areas that had great potential. With some good spots in mind, I progressed to the reception area.

> "It was a great opportunity for me to get detail shots for the vendors who were supplying the wedding."

The reception venue was being prepared for the evening, so it was a great opportunity for me to get detail shots for the various vendors who were supplying the wedding. To create these, I used my 85mm f/1.4 lens wide open to isolate the individual elements, picking out any small feature that went into the look and feel of the wedding. These tiny details are the unique signature of each wedding, chosen by the bridal couple to express their individuality. I shot the menus, the flowers, the crystal glasses, the knives and forks—anything that had some significance to the theme (4-35). Once I was satisfied that I had some nice detail shots for the reception part of the wedding storybook, I went back inside to find Claire.

PRO TIP >
## Wait Until It's Perfect

I don't like taking pictures of anyone half made-up. It's not particularly flattering and usually the bridesmaids take care of these "funny" snaps with their own cameras. I would rather the makeup artist complete their job, so I get on with shooting detail images in the meantime.

**4-35.** Detail shots at the reception venue, which happened to be the same place where Claire was preparing for the wedding.

12:00PM **The Bride's Makeup**

When I got back to the dressing room, Claire's makeup was complete, so it was time to start her photography. Again, I avoid taking pictures of brides when they are half made-up. Not only is it unflattering, but it also interferes with the makeup artist while she is doing her job. I prefer to let the artist finish what she is doing before I start taking pictures. Then, I simply ask the makeup artist to re-enact the preparations. This allows me to freely direct the bride and position the artist's hands/tools in an appealing way.

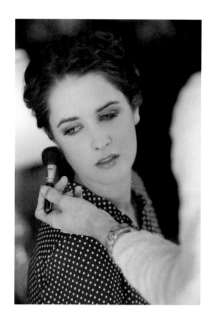

**4-36, 4-37, 4-38 (ABOVE).** After the makeup was completed, I had the bride and makeup artist do some re-enactment shots.

**4-39, 4-40, 4-41 (LEFT AND BELOW).** Having Claire drop her shirt off one shoulder created a clean view of the completed look.

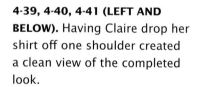

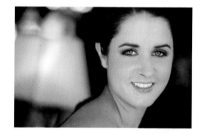

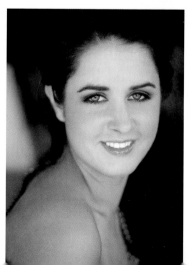

I photographed the individual bridesmaids with their makeup application, then finished up with a makeup re-enactment featuring Claire by herself (4-36, 4-37, 4-38). Finally, I asked Claire to slip her shirt off one shoulder for nice, clean look with the completed styling. I shot a few variations of this look (4-39, 4-40, 4-41). The makeup images were shot at f/2.8 and ISO 2000 at $\frac{1}{640}$ second on the 70–200 f/2.8 lens.

In postproduction, I did my retouching on the color images, then converted them to black & white. However, I also save a finished color version of each image to give to the makeup artist for her marketing purposes. Understandably, makeup artists don't favor black & white images, since their job is all about the selection and blending of colors (4-42, 4-43).

**4-42, 4-43.** For the makeup artist, color versions of the images are preferred.

### 12:20PM The Gown, Bridal Portraits, and More Detail Shots

**Photographing the Gown.** Next, we proceeded upstairs to the mother of the bride's bedroom, where we were going to do some formals of Claire. I asked the dress designer to tell me a bit about the gown and learned that it was a two-part dress; there was an outer layer that fit around a beautiful, sleek gown. It is an absolutely gorgeous, vast dress with a huge petticoat, so it wasn't very easy to shoot in one image. Hanging the dress in the window, I shot two images, which I later joined in postproduction. I also photographed the sleeker version by itself. In the storybook, I envisioned possibly showing the two shots together to reveal the very clever design of the gown (4-44, 4-45). I photographed the dress with the 70–200 f/2.8 lens at f/2.8. I needed +3 stops expo-

sure compensation to make up for the intense backlighting and the very light color of the dress.

I asked Claire to remove the top she was wearing and wrap herself in a white towel. With her veil in place, I made some happy, serene shots of her. For a clean high-key look, I overexposed by 1 stop. Once again, I shot several variations (4-46, 4-47, 4-48). At this stage, I was not really sure which images I was going to use in the album, but I thought I might use five or six shots from the sequence in my design.

I then asked Claire to start getting into her gown, but not to fully zip or button it up. I stepped out of the room and asked her to call me when she was ready to photograph the next step.

"I asked Claire to remove the top she was wearing and wrap herself in a white towel."

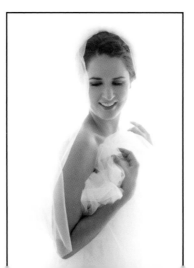

**4-46, 4-47, 4-48 (LEFT AND FACING PAGE).** Wrapped in a towel and wearing her veil, Claire has a pure, happy look.

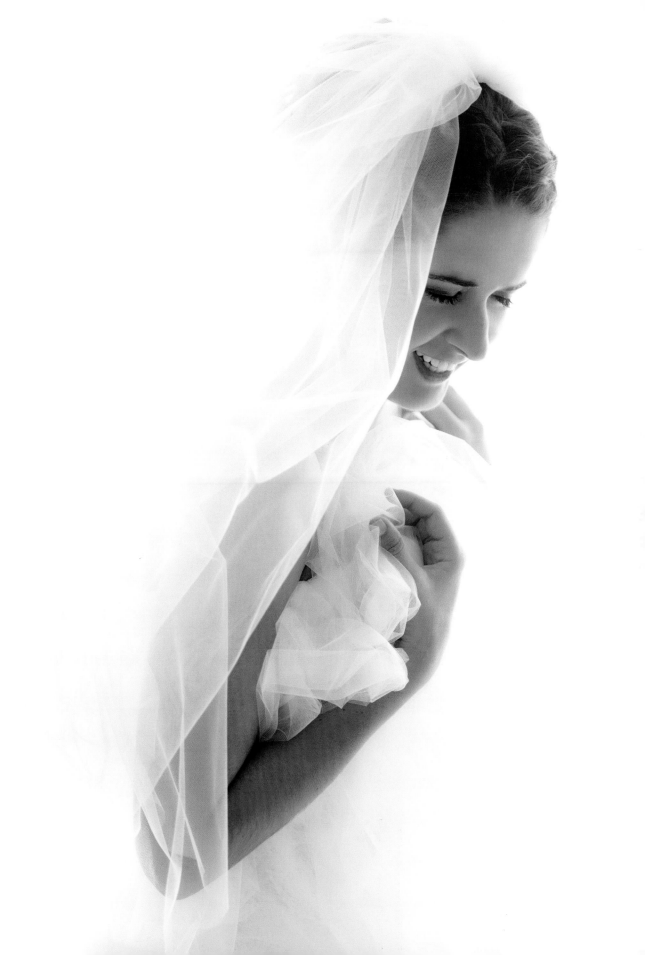

# The Bride's Accessories

While she was dressing, I utilized the time to shoot Claire's accessories, which included her shoes, perfume, earrings, the rings, and other small items (4-49, 4-50). For a backdrop, I used one of the bridesmaid's dresses, which naturally reflected the color scheme of the wedding and would perfectly suit the album design. At this point, Claire was ready for me to resume shooting her preparations.

**4-49, 4-50.** Detail shots of the bride's accessories photographed on a bridesmaid's dress.

## 12:30PM Bridal Portraits and the Bouquet

**A Fashion-Inspired Look.** The week before Claire's wedding, I had seen an editorial fashion shoot by Camilla Akrans in *Harper's Bazaar* magazine. The story included beautiful back-lit images against a clean background. These were then processed with a very warm orange/red cast. I loved the style and wanted to emulate it in these images.

I started by shooting some portraits of Claire with her back bare and the inner part of the dress not fully buttoned up (4-51, 4-52). Claire then put on the outer layer of her dress and looked absolutely gorgeous, so we shot a few more

"I started by shooting some portraits of Claire with her back bare."

**4-51, 4-52.** Stylish backlit images of Claire getting dressed.

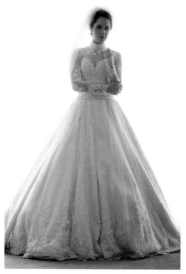

**4-53, 4-54, 4-55, 4-56, 4-57.** Posing variations with Claire in her full gown.

images under the same lighting conditions (4-53, 4-54, 4-55, 4-56, 4-57). In terms of posing, I think it's important to move from one pose to another in an effortless way. Here, I started off with both arms to her side. I then asked Claire to move her right arm to her left wrist, then her left wrist up to her shoulder. Next, I had her put one hand on her hip and let the other hand hang down. For the last shot, I asked her to hold onto her dress. That's five or six poses accomplished within

"This is easy to do and gives you some nice options for the storybook design."

30 seconds. This is easy to do and gives you some nice options for the storybook design.

This completed the backlit shots. However, I want to point out that if you look back to the "getting ready" images of Chris (4-7 through 4-16), you'll see that they were shot in a very similar way. This created a visual parallel between the bride's and groom's preparations, adding continuity to the story of the wedding I'll be presenting in the couple's album.

**A Classic Look.** As I did with Chris (4-17 through 4-20), my last sequence of individual image with Claire consisted of classic, beautiful portraits designed to have broad appeal. I posed her against some lovely antique-looking wallpaper that suited the style of her dress (4-58, 4-59, 4-60). I shot these images the 70–200 lens at f/2.8 at ISO 1000 with $+\frac{1}{3}$ stop exposure compensation. (The Nikon D4 is an amazing camera; at ISO 1000, I have absolutely no grain whatsoever,

**4-58, 4-59, 4-60.** Classic portraits of Claire that will please her parents.

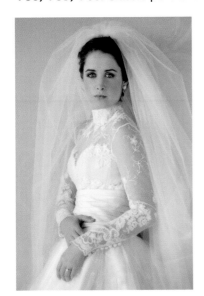

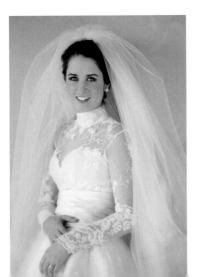

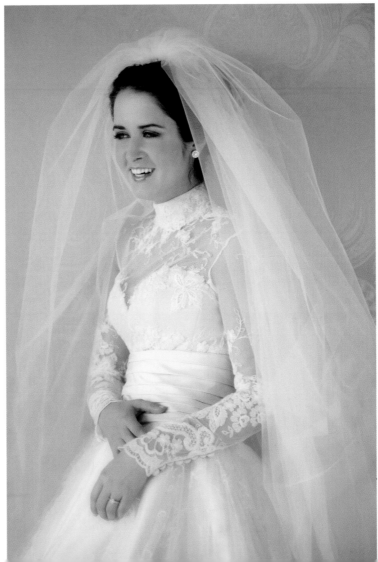

so I am happy to shoot bridal portraits at that setting.) At the same time, I also created a beautiful image of her bouquet for the florist and some pretty portraits of her holding the flowers (4-61, 4-62, 4-63).

## 1:00PM The Bride and Bridesmaids On Location

I had arranged for the bridesmaids to be ready at 1:00PM—and, due to the fact that I generally work with reliable suppliers and stylists, we were all ready on time.

**Group Portraits.** We moved down to the home's stables, a sentimental spot for Claire, where I had decided to photograph the bride and her bridesmaids. I had asked the horse groom to arrange bales of hay for the bridesmaids to sit on. Once everyone had congregated at the stable area, I positioned the ladies on and around the bales of hay to

**4-61, 4-62, 4-63.** Claire with her bouquet, plus a tighter view that will be a nice image for the florist.

**4-64, 4-65, 4-66.** Rather than trying to rearrange the whole group, I created variations through different expressions and interactions.

stagger the levels of their faces in the images. I used what I like to think of as a *Vanity Fair* or *Vogue* type of arrangement, where each bridesmaid is in a different posture rather than posed very uniformly.

To get some variations, I called for a few different emotions and interactions, having them look at me with quite a serious look, then laugh, smile, and chat with each other (4-64, 4-65, 4-66). To get options for the album, this is much easier than trying to completely reposition everyone. Using this

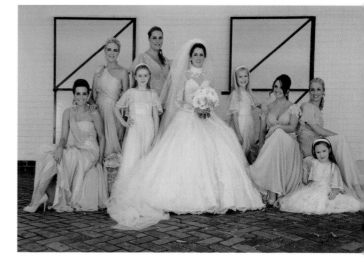

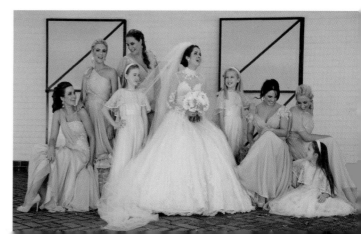

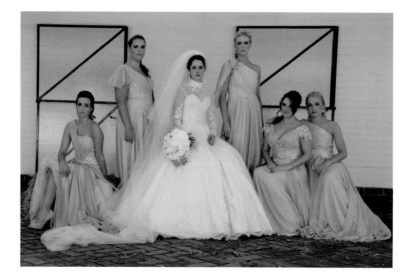

**4-67.** After images with the whole bridal party, I asked the little girls to step out of the frame and created some images of the bride and her bridesmaids

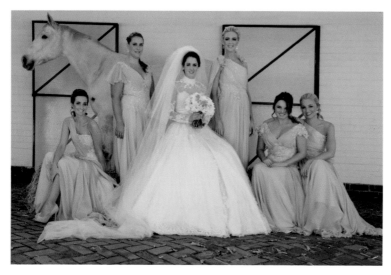

**4-68.** The prize shot included Claire's favorite horse. The groom who positioned him was Photoshopped out of the final presentation.

setup, I did a shot of all the ladies, including the flower girls. Then I asked the little girls to stand aside and photographed the bride with just her bridesmaids (4-67).

The biggest challenge was getting an image of Claire's favorite horse standing behind the bridesmaids in a very editorial type of shot. We weren't sure if he was going to cooperate because there was only a very small space between the bridesmaids and the stable doors, but one of the grooms assisted; I simply Photoshopped him out of the final image (4-68). The result was a gorgeous shot that is very reminiscent of *Vogue* or *Vanity Fair*.

**Claire with Her Horse.** At the same location, I took a few shots of Claire with her horse. I wanted it to be almost implied that

the animal was there (4-69, 4-70, 4-71); showing the bride and her horse with their heads together looking into the camera would have been a bit cliché. My favorite shot is the one where you see the horse's huge chest in the background. I also like the shot where his back and neck are framing Claire.

For all of these shots at the stable, there was a lot of bright sunlight bouncing off a wall behind me, so I didn't use any light manipulation on Claire or the bridesmaids. For the group portraits, I shot at ISO 400 and $1/200$ second at f/10 to get the depth of field required to keep everyone in focus, from the front of the group to the back. For the shot of Claire with her horse, I shot at f/2.8. Again, the available light was just beautiful and bouncing around everywhere.

**4-69, 4-70, 4-71.** Claire was photographed with her favorite horse.

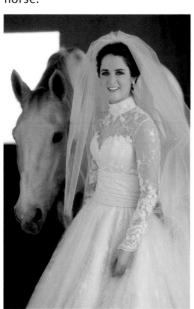

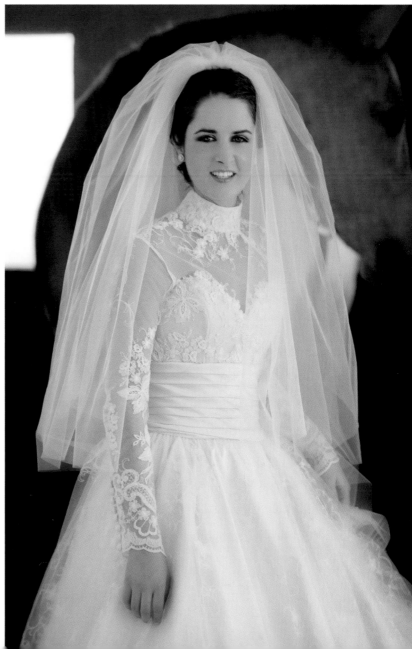

**4-72, 4-73, 4-74, 4-75.** Individual portraits of the bridesmaids.

"The light was great, so all I needed to add was some fill from a collapsible reflector."

1:30PM **The Bride's Retinue**

**Individual Portraits of the Bridesmaids.** We moved on to a different location, a quaint storeroom where bales of straw were kept, to photograph the bridesmaids individually—just as I had done with the groomsmen. As I did with the guys, I made sure that I had a few options with each bridesmaid (4-72,

4-73, 4-74, 4-75). The light was great, so all I needed to add was some fill from a collapsible reflector. Brandon, my assistant, held the reflector to the camera-right side of each bridesmaid. I shot these portraits at f/2.8 and $^1/_{200}$ second at ISO 400.

**The Flower Girls.** Next, I created portraits of the flower girls individually and as a

group. For the group shot, I positioned them tightly together so that their faces were all the same distance from me. This meant I could still shoot a f/2.8 and keep them sharp against an out-of-focus background (4-76, 4-77, 4-78, 4-79). That took me to 2:00PM, which was the time at which I was due to leave the home and head to the church.

**4-76, 4-77, 4-78, 4-79.** The flower girls, individually and together.

# At the Church

## Professionalism

**Punctuality.** I arrived at 2:15PM and immediately walked into the church to make it known that I was present. I feel it's important for the arriving guests to see that I'm there. This lets them know that if the bride is fashionably late, it's not because I have delayed her. I offer a highly professional service and impeccable timing is one of my rules. I'm always on time and I am never the cause of a delay in the day's proceedings.

**Appearance.** Another rule that ensures my professional image concerns the way my assistant and I are dressed for the occasion. I had been wearing jeans and a t-shirt during the early part of the morning, but by this time both my assistant and I had changed into smart dark trousers, black shoes, and long-sleeved black shirts with my subtle Nikon branding. It's imperative that we both look professional because I want people to understand that I take my business as a professional photographer very seriously.

"I am never the cause of a delay in the day's proceedings."

PRO TIP >
### Be Ready!

The ceremony is probably the single most important aspect of the entire wedding day. Because you, as the photographer, are not in control of the sequence of events, it's essential that you are on the ball and ready to document each important moment as it happens.

**Before the Bride Arrives**

**Meet the Officiant.** After checking in with Chris to see how his day had gone since I left the boys, I found the marriage officiant and introduced myself to him. I also inquired as to whether he or the venue had any rules or regulations pertaining to photography. I find that it is important to maintain good relations with people in the industry. If the marriage officiant does have some rules (sometimes no flash photography inside the church or a request to refrain from shooting during the vows) you should be aware of them beforehand and adhere to the guidelines. They will appreciate the courtesy.

In this case, I found the minister to be very relaxed—and he was very happy that I had introduced myself to him. He said that there were no fundamental rules but did ask that I be discreet with the camera and try not to be too distracting. As long as I was subtle about it, I could take as many pictures as I liked. He understood that photographs of the ceremony were going to be very important to Chris and Claire.

**The Groom and Groomsmen Waiting.** From there, I went to shoot a few images of Chris (5-1, 5-2) and his groomsmen (5-3) waiting in the pews at the front of the church. Chris looked very serious, probably succumbing to a few nerves as he waited anxiously, so I cracked a joke and he livened up quite a bit. These sorts of shots go a long way in telling the story of the day in the couple's album. I could already envision

**5-1, 5-2.** Chris was at the front of the church, waiting for his bride to arrive.

**5-3.** Waiting in the pews for Claire's arrival.

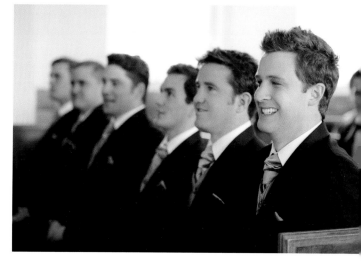

pairing these images of him waiting with images of Claire arriving and getting out of the car. Placing these on facing pages would let viewers know that the two things (him waiting, her arriving) were happening at the same time. I shot these images of the guys with the 70–200mm f/2.8 lens at f/2.8 and $^1/_{100}$ second at ISO 4000.

2:50PM **Here Comes the Bride**

**Through the Car Window.** The wedding was scheduled for 2:30PM, but Claire had told me she planned to arrive fashionably late at 2:45PM, so I was in place when she pulled up at 2:50PM—and, even then, some of the guests were still arriving! While she was waiting to step out of the car, I got some beautiful shots of her through the car

5-4, 5-5. Claire waited in the car while a few late-arriving guests made their way into the church.

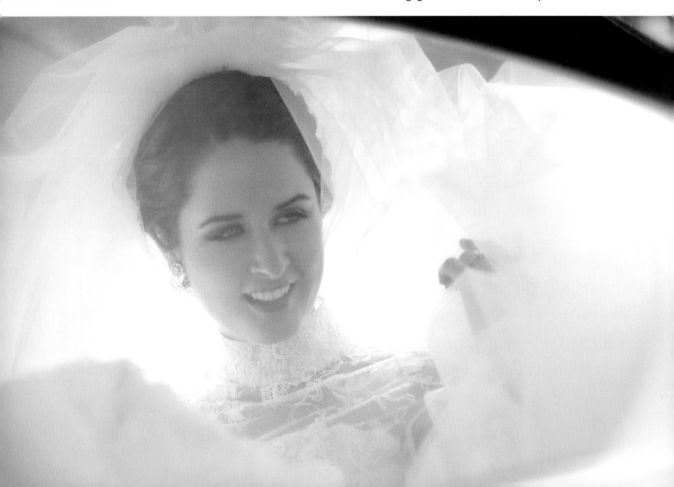

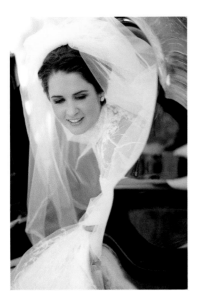

**5-6.** Claire stepping out of the car.

window, watching her tardy guests from the privacy of the vehicle (5-4, 5-5). From those photographs, one gets a feeling of separation between the bride and her guests because the glass caused a little bit of diffraction. The images have a nice, soft look because of the beautiful lighting coming through from the rear window and falling around her neck area. I shot these images at ISO 400 and f/2.8 at $\frac{1}{320}$ second. Because of all the white in the scene, I used $+\frac{2}{3}$ stop exposure compensation.

**Exiting the Car.** When it was time for Claire to get out of the car, I took a shot of her perched on the edge of the seat as she was leaning out of the car (5-6). There was a great reflection on the side of the car, which added to the shot.

**The Bride and Her Father.** Before they entered the church, I captured a series of images of Claire with her dad, Keith (5-7, 5-8, 5-9). This is significant moment for a father and his daughter, and Keith gave Claire a beautiful kiss on the cheek. These three lovely shots of the father and daughter together are something I'm quite sure they will cherish forever. Because their faces were at the same distance from me, I was able to shoot the portraits at f/2.8, for a nice, soft background behind the clean, sharp subjects. I shot this at ISO 640 and $\frac{1}{800}$ second.

**5-7, 5-8, 5-9.** Claire and her dad during the big moment before entering the church.

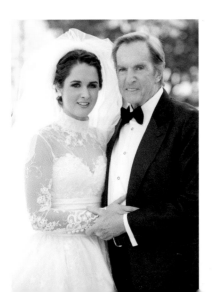
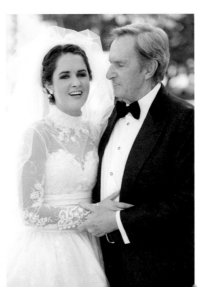
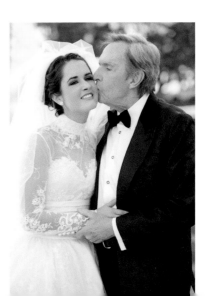

**The Ceremony**

**The Groom's Reaction.** Once I had my shots of the bride arriving and the father/daughter images, I quickly positioned myself halfway down the aisle and made sure to capture a shot of Chris watching as his bride and her retinue entered the church (5-10, 5-11). The expected shot at this particular moment is of the bride coming down the aisle, but it is equally important to get the groom's reaction to the people entering the church, the bridesmaids walking down the aisle, and (obviously) seeing his bride for the first time. I shot these at f/2.8 at $^1/_{125}$ second at ISO 4000.

**The Bridesmaids and Flower Girls in the Aisle.** I then turned around and photographed the bridesmaids and flower girls coming down the aisle (5-12, 5-13). I am not necessarily going to use images like these in the album, but I shoot them anyway so that I have the opportunity to sell the prints. This expands the audience for my work and gives me potential future jobs from guests at the wedding.

"I quickly positioned myself halfway down the aisle . . ."

**5-10, 5-11.** Chris at the front of the church, reacting to the arrival of the bride's party.

**5-12, 5-13.** Next, I photographed the flower girls and bridesmaids coming down the aisle.

# The Bride and Her Father in the Aisle

When it was time for Claire to walk down the aisle, I switched my autofocus system to AFC and 3D tracking so that, as Claire walked toward me, I knew she would stay in focus. It is important to know all the technical aspects of your equipment in and out, so that you can change these things on the fly. On their way down the aisle, there was a beautiful moment between Keith and his daughter, and I managed to get a nice sequence of crisp, sharp images (5-14, 5-15, 5-16, 5-17).

**5-14, 5-15, 5-16, 5-17.** Speed was required to capture this moment between Claire and her father as they walked down the aisle.

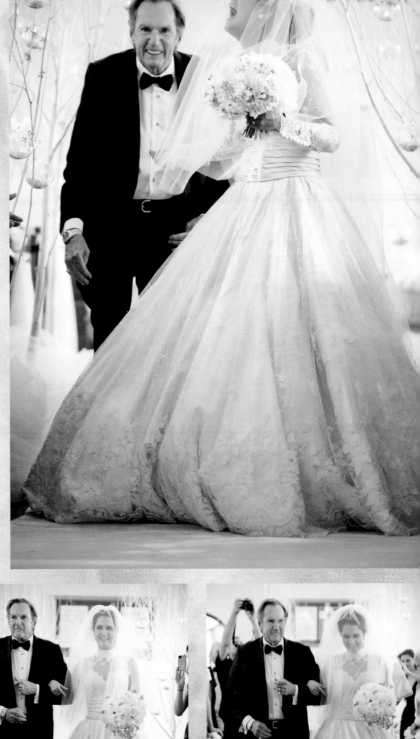

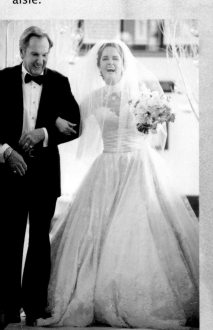

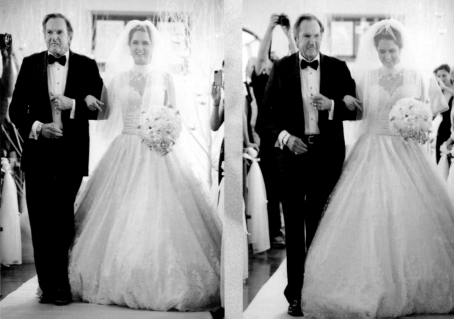

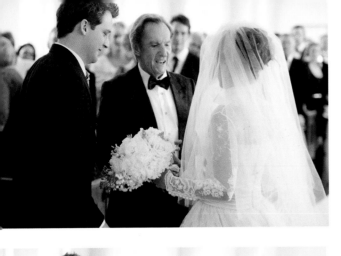
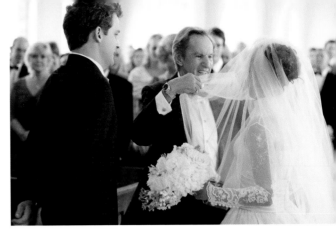
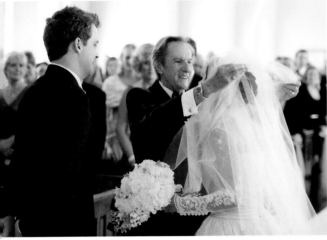
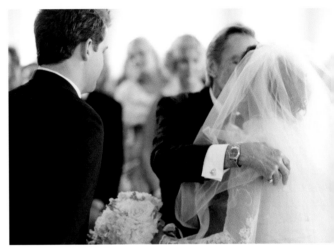
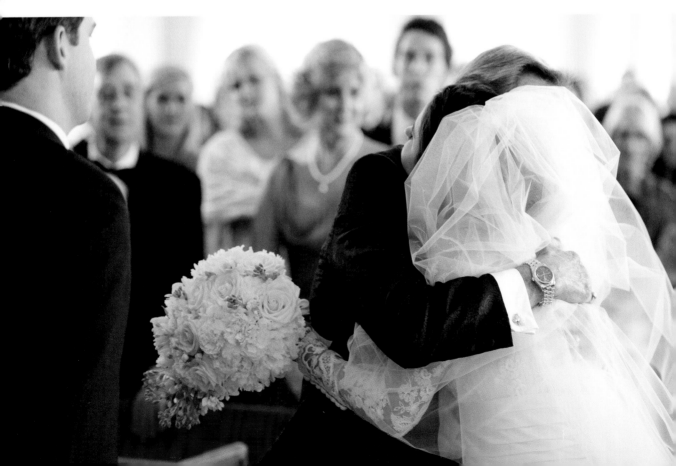

**5-18, 5-19, 5-20, 5-21, 5-22 (FACING PAGE).** A sequence of images showing Keith and Claire arriving at the altar with Chris looking on.

**Unveiling the Bride.** When Keith got to the end of the aisle to greet Chris, I switched the focus to AFS and single point. I activate the focus by pressing the AF button on the back of the D4 with my thumb. This temporarily holds the focus while I keep my index finger on the shutter button and fire at will. This technique allowed me to get a fast sequence of images as Keith lifted Claire's veil, then leaned in for a kiss and a hug. I got about fifteen or twenty shots of this interaction, so I had lots of choices when picking the perfect moments for the storybook (5-18, 5-19, 5-20, 5-21, 5-22).

**A Quick Break.** Once this sequence was done, I didn't start shooting immediately. I knew there would be ample time to get some great shots later, so I just let the bridal couple enjoy the moment and held off four or five minutes before I resumed shooting. I think that standing together at the end of the aisle

> "I don't want to get in the way of the couple's guests watching the proceedings."

for the first time is a sacred moment that needs to be treated as such. Additionally, I don't want to be the center of attention or get in the way of the couple's guests watching the proceedings.

## PRO TIP > Be On the Lookout

As the congregation began to sing the chosen hymn, I noticed that there was a little interaction between Claire and Chris, so at this point I fired off a few frames and was rewarded with a beautiful shot of Claire whispering into his ear (5-23). I shot this unanticipated moment at f/2.8 and $^{1}/_{60}$ second—a slow speed that had the potential to be problematic. Fortunately, I managed to hold the camera steady enough to get a great shot.

**5-23.** A candid image of Claire whispering to Chris as the congregation sang.

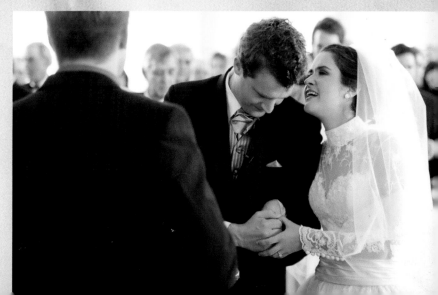

**Readings.** During the hymns, I got a few shots of the guests singing, then moved around to the front of the church to capture an images of Claire's siblings giving their readings (5-24, 5-25). I got good shots at f/2.8 and $^1/_{160}$ second.

**Parents and Grandparents Watching the Ceremony.** During the readings, I noticed how much the parents were enjoying the proceedings and took the opportunity to get individual shots of all of them (5-26, 5-27, 5-28, 5-29). I also noticed the groom's grandparents watching intently and saw the opportunity for a great shot of them (5-30).

**5-24. 5-25 (ABOVE).** Readings by Claire's siblings.

**5-26. 5-27, 5-28, 5-29 (BELOW AND FACING PAGE BOTTOM).** Images of the couple's parents enjoying the readings.

**5-30 (ABOVE).** The grandparents of the groom, photographed during the readings.

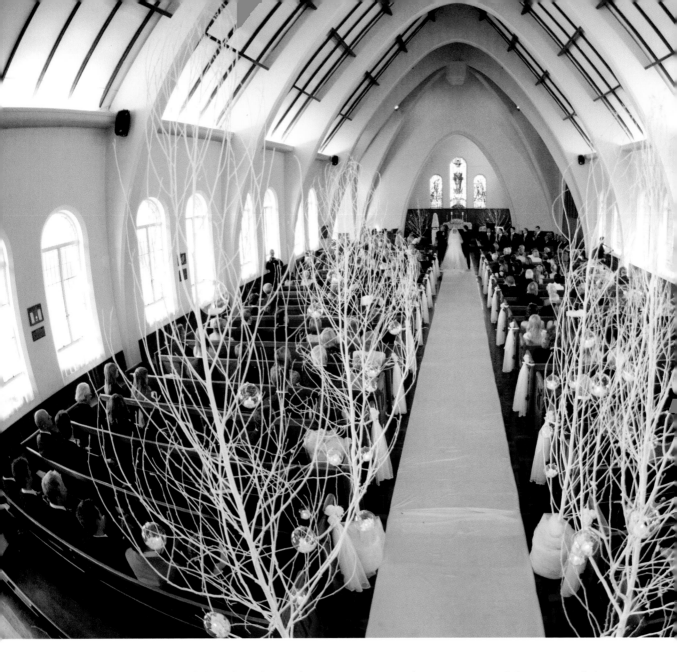

**From the Back of the Church.** As the minister started his sermon, it was time for me to head quietly to the back of the church. With my camera on a monopod, I activated the self-timer (which was set to wait 5 seconds, then shoot four images at 1-second intervals). I focused on the bride and groom, triggered the countdown on the shutter, and elevated the camera to get an aerial view of the church from the back

**5-31.** A fisheye view of the church interior, the couple, and all the assembled guests.

(5-31). Using a 10.5mm fisheye lens, I got a wonderful perspective of the proceedings and the whole atmosphere of the church. Shooting four frames at 1-second intervals left time to adjust the camera angle/tilt between frames, so I could choose the best pictures for the storybook. Changing back to my 70–200mm f/2.8 lens, I also shot up the aisle for a lovely image of the couple (5-32).

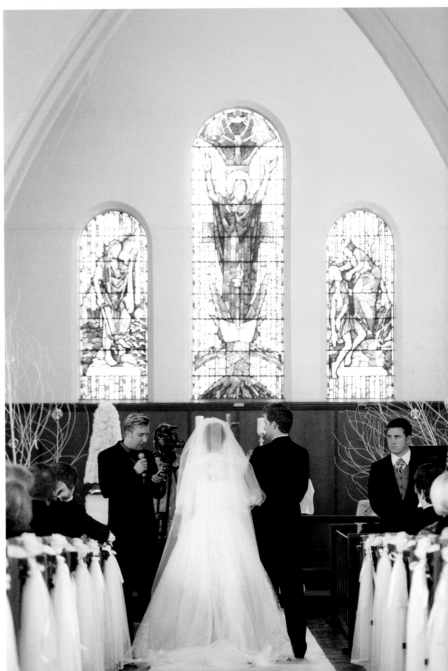

**5-32.** Switching back to the 70–200mm lens, I photographed the couple.

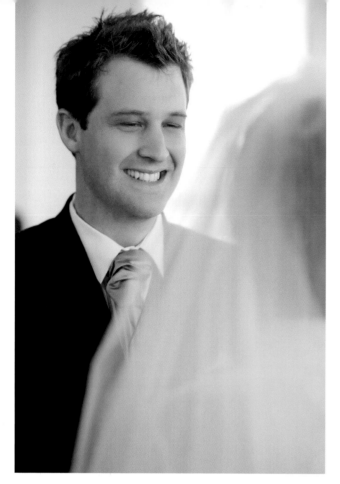

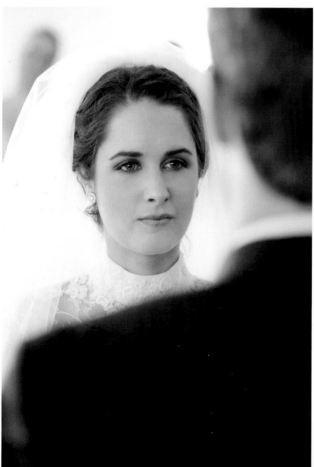

**5-33, 5-34 (LEFT).** Close shots help reveal the bride's and groom's emotions.

**The Vows.** By this stage, it was time for the vows. I like to shoot the vows from directly behind the shoulder of the person who is speaking, using them to frame the shot. Claire was first to give her vows, so I moved in behind her to focus on Chris's reaction and the emotion in his eyes while he was looking at her. I move in as close as possible when I am framing these images, because I want to convey what it feels like for her to be looking at her groom and for him to be looking at his bride. The pictures are very intimate and speak a great deal about the love that the couple have for each other (5-33, 5-34). I then moved to another position so that I could get a different angle, giving me some additional options for the storybook (5-35).

**5-35.** A slightly different view gives me another option when designing the storybook.

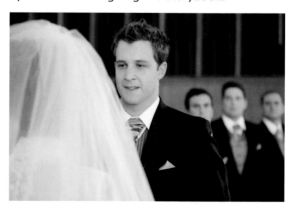

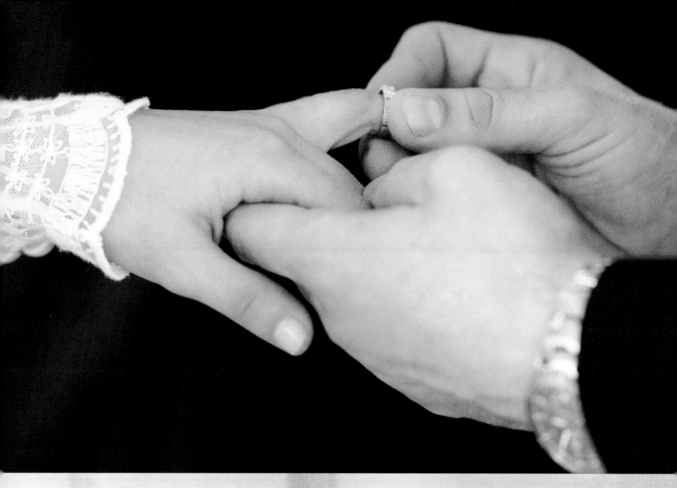

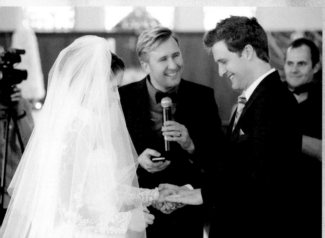 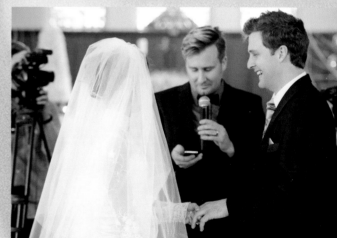

**5-36, 5-37, 5-38.** The ring exchange, captured in tight and wider views.

## PRO TIP > The Ring Exchange

With the vows over, it was time for the couple's ring exchange (5-36, 5-37, 5-38), so I zoomed in for a nice tight shot of the ring going onto Claire's finger. Then I went with a wider shot to give me more options for the album. Finally, I captured an image of Claire giving Chris his ring—and a great interaction of the couple with the marriage official. Again, different angles and perspectives give you plenty of options when designing the couple's album.

**The First Kiss.** For their first kiss as husband and wife, I again activated the D4's AF button with my thumb and focused on Chris's face. I picked Chris because it is easier to focus on an area where there is a bit of contrast (as op-

**5-39, 5-40, 5-41, 5-42, 5-43.** The first kiss and ensuing hugs.

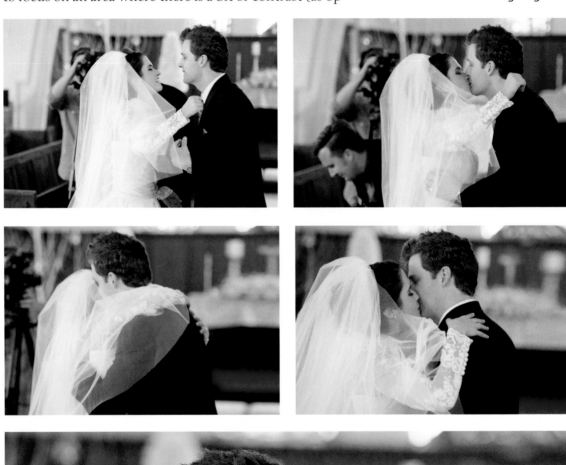

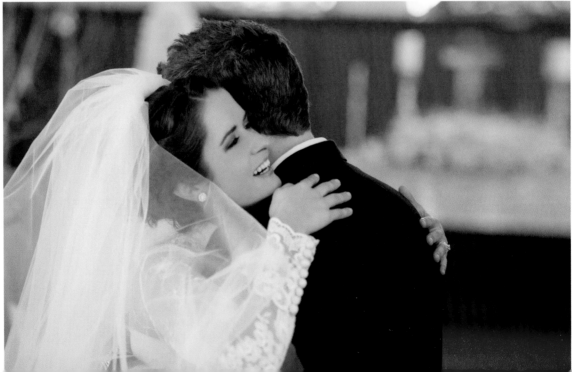

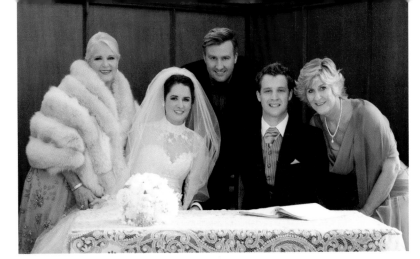

**5-44.** The witnesses and the marriage officiant "signing" the register.

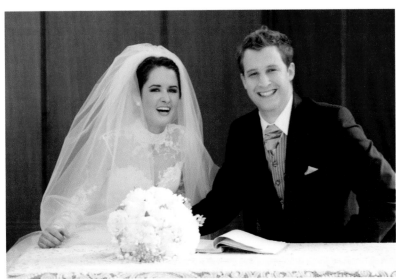

**5-45.** I cracked a joke to get a nice shot of the happy couple.

posed to the veil and the white dress of the bride). With my focus "held" by my thumb, I captured five or six shots of the kiss and ensuing hugs, which gave me more lovely options for the album (5-39, 5-40, 5-41, 5-42, 5-43).

**Signing the Marriage Register.** At that stage of the proceedings, it was time to sign the marriage register. I always let the officiant handle the legal proceedings first, as I don't want to be responsible for any mistakes on important documents. Once they were done, I stepped in to shoot very official-looking photographs of the witnesses and the marriage officiant "signing" the register (5-44). These images were shot at f/5 because I needed more depth of field to hold focus on the marriage officiant, who was standing behind Claire and Chris. While they were signing the register, hymns were being sung for the entertainment of the guests. Having gotten my serious shot, I felt I needed a more

relaxed pose, so I cracked a joke that resulted in a nice, happy image (5-45).

**The Blessing.** From there, the couple and officiant returned to their previous positions and a blessing was given (5-46). I shot this at ISO 6400 and f/3.2 at $\frac{1}{200}$ second because it was quite dark up at the front of the church.

**The Couple Walking Up the Aisle.** I then moved to the middle of the aisle where I set my autofocus to AFC (continual focus and 3D tracking) to capture each step as Claire and Chris walked up the aisle as a married couple (5-47, 5-48, 5-49). I continued to shoot this at f/3.2. I hadn't changed my setting and liked having a little more depth of field in case one of them was a tiny bit behind the other.

**First Formal Portrait of the Married Couple.** Once I knew I had my aisle shots, I immediately changed to ISO 400. I set my autofocus to single servo and set the focusing system to single focus point so I was ready to take a formal photo of the couple at the front of the church. This important photograph is the first "formal" portrait of the officially

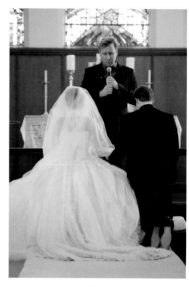

**5-46.** The final blessing.

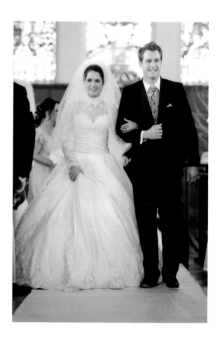

**5-47, 5-48, 5-49.** Chris and Claire walking up the aisle.

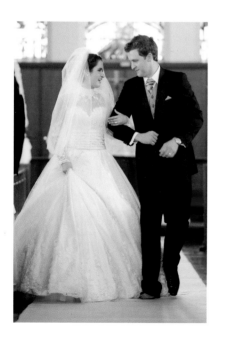

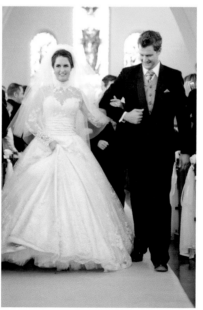

**5-50, 5-51.** The first portraits of the married couple.

"This important photograph is the first 'formal' portrait of the officially married couple."

married couple, and it is bound to have pride of place on the mantelpiece. You have to get it right—and you have to get it *quickly*, because the guests will be following them out of the church in no time. In this case, there was nice light coming through the door and a white wall to use as a background, so I managed to shoot two gorgeous shots of Chris and Claire at the entrance to the church (5-50, 5-51).

## 3:35PM Outside the Church

I moved quickly so as not to hold up the proceedings. At this stage, all the guests poured out of the church to mingle and offer their good wishes to the couple.

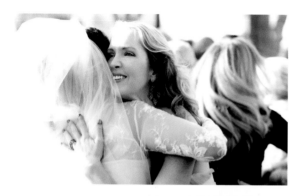

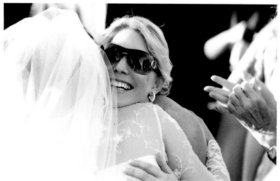

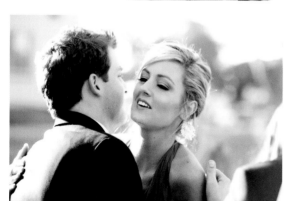

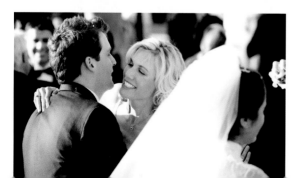

**Congratulations!** As the bridal couple walks out of the church, I always direct them into a position where they are facing the sun. It might be a little uncomfortable for them, but the guests look beautiful with the backlighting. Those are the faces we want to see in these shots. And, if I can get the guests to look gorgeous, there is more potential for me to book them as future clients! It may seem cunning, but we are here to make a success of our photography careers, and this is one of the subtle ways of going about it.

Again, I isolated the subjects by shooting them with a shallow depth of field. I worked at f/3.2 and ISO 400. I shot in aperture priority so my shutter speed ranged from

**5-52, 5-53, 5-54, 5-55, 5-56, 5-57.** The guests were backlit for photos as they congratulated the bride and groom

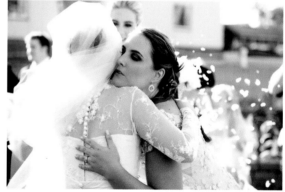

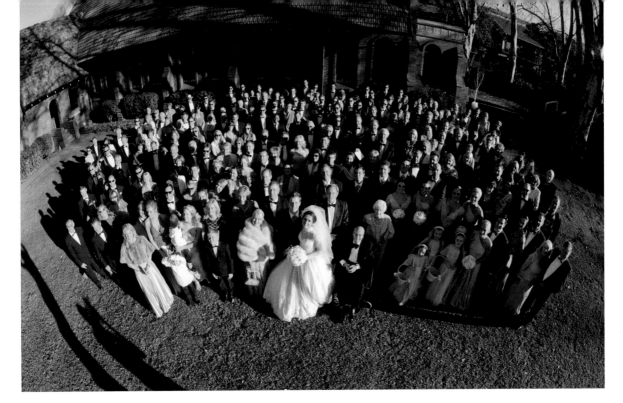

**5-58.** A wide shot of the whole group.

$\frac{1}{500}$ to $\frac{1}{1600}$ second. I try to photograph as many guests as possible (5-52, 5-53, 5-54, 5-55, 5-56, 5-57). It just adds options for the couple's album—and, once again, you never know which one of them might end up being a new client.

**A Big Group Portrait.** I like to take a big group shot of everyone who attended the wedding, but trying to herd people together at the reception is nearly impossible. So, as soon as the congratulations are done, I make the announcement that I need everyone to gather together at a designated spot so I can take a group shot. At this particular wedding, the light was shining directly into the

chapel, so capturing the front of the chapel in the background would have meant having the guests staring directly into the sun. To have them backlit, I would have had to shoot in the parking lot.

> "I switched to a fisheye lens and raised the camera on a monopod above my head."

For this reason, I had everyone go to the side of the chapel (5-58). This side-lit the group, which is not particularly flattering lighting, but it was the best option. Again, I switched to a fisheye lens and raised the camera on a monopod above my head to make sure that I got everybody in. In this im-

**5-59.** I start with a large group shot of everyone who is related to the bride and groom.

age, it's not important that the bridal couple be able to identify every single face. You just want a nice, big shot to show the whole group of family and friends who gathered for the special event.

### 3:45PM Family Portraits

**Setup.** While I was making the group shot, my assistant set up the Elinchrom Ranger RX for the family photographs. The chapel was on the grounds of a school, so we found a nice open area on the cricket field. It had a pretty background, and it was in the shade so there was a nice level of contrast.

**Lighting.** For these portraits, I used the Ranger as fill flash, shooting it with a bare bulb for maximum power to fill the large groups. I had the flash about 15 meters (50 feet) from the group just to soften the light a little, so I didn't have harsh shadows.

**Poses.** With my group shots, I try to use a variety of poses. I don't like everyone to stand in a long line facing the couple. I used my Pelican case as a seat for the sisters of the bride, then grouped people around them. I also carried in a small bench that I found nearby and had the groom's sister sit on it, just to add some interest to the composition.

**Groupings.** I started by shooting the entire family—everyone who is related to the bride and groom (5-59). I understand that there are complicated family dynamics in this day and age of divorces and new spouses, but I expect that people will put their differences aside for this special occasion.

Then, I move onto combinations of the family members, including the parents, grandparents, siblings, and nieces or nephews. Obviously, I am looking at the possibility of selling reprints here, so the more

combinations I can make, the more sales potential I have. I started with shooting the groom's family in all its variations, then I moved onto the bride's family—making sure the grandparents were photographed as soon as possible so they could go and sit down.

**Release the Parents.** Once these images are done, the parents can go off to tend to the guests. They are essentially the hosts of the event, so taking them away for too long is rude and not a good reflection on you as a photographer.

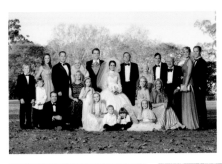

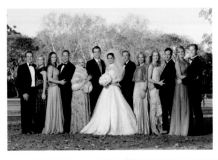

"Taking them away for too long is rude and not a good reflection on you as a photographer."

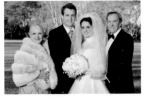

**5-60, 5-61, 5-62, 5-63, 5-64, 5-65, 5-66, 5-67, 5-68.** Get as many groupings of the family members as possible to maximize your reprint sales after the event.

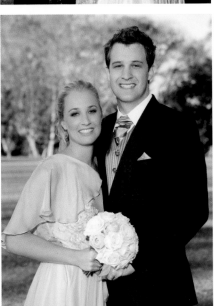

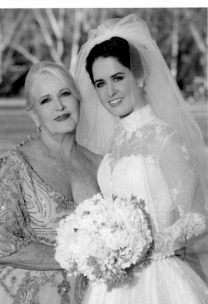

## 4:30PM Bridal Party Portraits

With the family portraits done, we can now focus on the bridal party. This is where the fun begins; it's time to be a bit more creative.

**Efficiency.** I limit myself to about 45 minutes or an hour for these images. For the guests, it is very annoying to have the bridal party go off for two hours on a photo shoot and leave them unattended. And remember: the guests are your potential future clients. Fortunately, I already photographed all the guys in the morning and all the ladies before

**5-69, 5-70, 5-71, 5-72.** Variety was added through the use of different expressions and interactions.

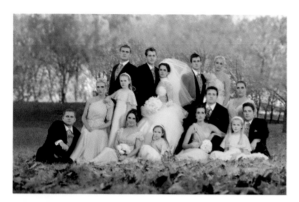

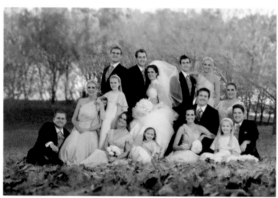

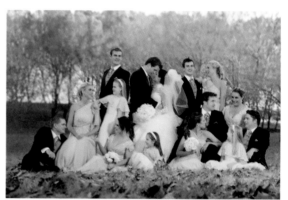

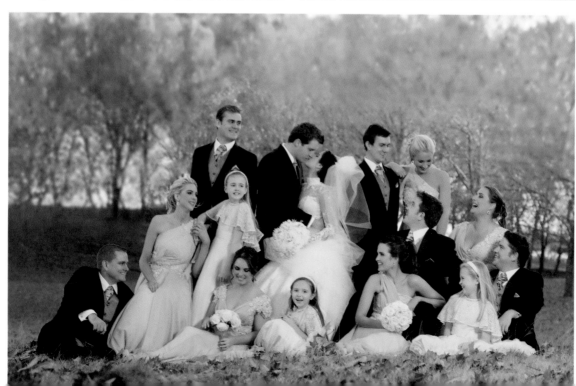

going to the church. Having those images out of the way reduced the amount of time I needed to devote to portraits in between the ceremony and the reception.

**Location Selection.** For this wedding, we had chosen a shooting area that was about ten minutes from the chapel and en route to Claire's parents home (where the reception was being held). The venue was at a race-horse training facility called Summerveld—in keeping with the wedding's equestrian theme.

We set up the Elinchrom Ranger with a white umbrella for nice, soft light and I positioned everybody in a regal pose that still had a fashionable feel. I shot a few variations, with the bridal party looking at me with serious faces, then laughing and smiling, talking to each other, looking in different directions, etc. (5-69, 5-70, 5-71, 5-72). My camera settings were f/6.3 at ISO 100 and $^1/_{100}$ second using the 70–200 f/2.8 lens. The exposure settings accentuated the warm colors in the background and the fill flash gave nice shape and form to the group. I didn't want to shoot at too small an aperture because I wanted the background foliage to be out of focus.

After the stationary bridal party shot, I asked the group to walk toward me as naturally as possible. This gave me more options

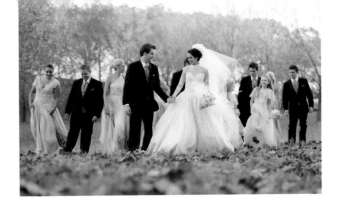

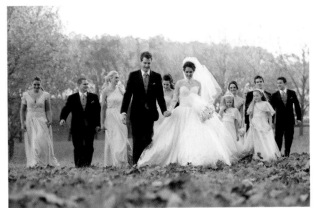

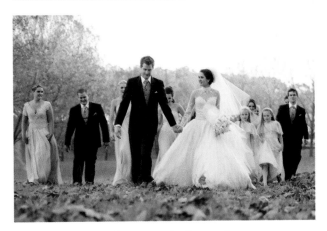

**5-73, 5-74, 5-75.** The group had to walk away from the shooting area where we did the stationary images, so I took advantage of the moment to create some natural images of them walking and interacting.

for the final album—and since they were all there as a group and had to walk away from where they were anyway, it made sense to

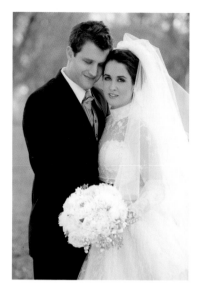
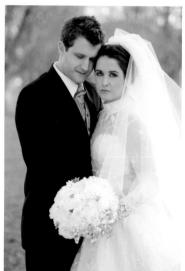
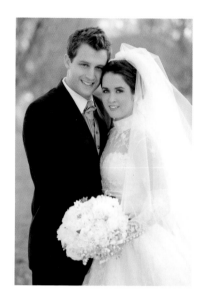

**5-76, 5-77, 5-78.** Some simple natural light shots of the couple.

take advantage of the moment. Asking them to go for a certain position as they walked back might have felt a little artificial or less spontaneous.

4:45PM **The Couple Together**

Apart from those driving in the car with Chris and Claire, everyone else was now free to join the other guests at the reception.

**A Second Location.** The rest of us drove a short way for a different background that was specifically for portraits of Claire and Chris. I took a few images of the two of them, making sure that I got some safe natural-light shots first (5-76, 5-77, 5-78). My exposure was f/2.8 at ISO 400 and $\frac{1}{100}$ second using the 70–200 f/2.8 lens.

To mix it up a little, I held a CD just off the lens for a nice reflection of the foliage and things in the background. It added an element of mystery—something gorgeous and unexpected in the shot (5-79, 5-80).

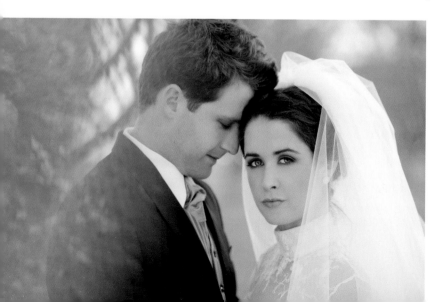

**5-79, 5-80.** I held a CD just off the lens to add some interesting reflections.

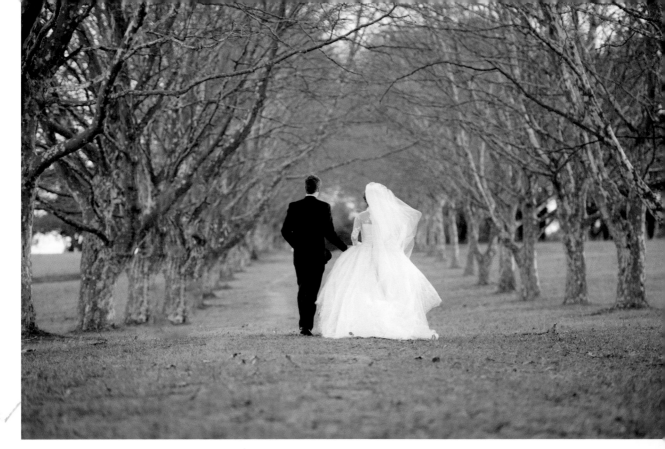

**5-81, 5-82.** I captured some natural interactions as the couple walked to our next shooting location.

PRO TIP >
# Wait for It . . .

You need a little bit of patience as you watch for spontaneous images to happen before you. Try not to let the time pressure get to you or make you rush things. It is much better to shoot eight fantastic images than twenty average ones.

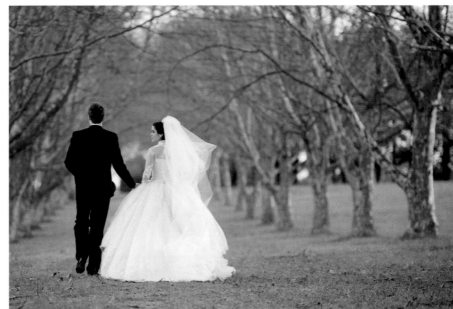

As we walked to another area, I photographed the couple from behind as they strolled down an avenue of trees, interacting with each other (5-81, 5-82).

At our next location, I shot with great backlighting, using +⅔ stop exposure compensation. Under this light, I captured some more "safe" shots as well as a few images of the two of them interacting and kissing, so that I had something a little more natural (5-83, 5-84, 5-85, 5-86).

Because we had already planned to do a post-wedding shoot, we didn't need to spend too much time on the two of them at this point. I focused on getting my safe shots, knowing I could spend much more time on creative looks at the day-after session (see chapter 7). We finished this part of the shoot at 5:00PM, with the actual shooting time taking all of about ten minutes.

**5-83, 5-84, 5-85, 5-86.** At the second location, I created a few more safe shots and captured some more natural interactions between Chris and Claire.

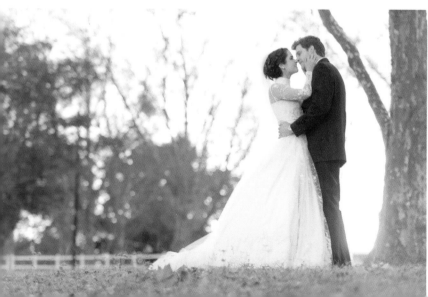

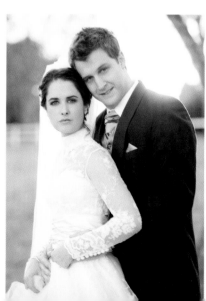

# Time to Celebrate

## 5:15PM | A Few More Detail Shots

I then drove back to the reception, which took 15 minutes. When I got there, I spent a few minutes shooting the tables again. When I had photographed the details here earlier in the day, it was bright daylight. That didn't give me the ambience that I wanted from the lit candles in the evening light.

## 5:30PM | The Reception Begins

**Arrival Shots.** The bridal party entered the marquee, the site of the outdoor reception, right on schedule. As they were entering, I had my assistant Brandon position LED lighting to enhance the mood. I photographed the bridesmaids and the grooms-

men entering on f/2.8 and ISO 4000 at $^{1}/_{100}$ second with the 24–70mm lens (6-1, 6-2). As Claire and Chris entered, I photographed them with the same settings, documenting

**6-1, 6-2.** The bridesmaids and groomsmen entering the reception.

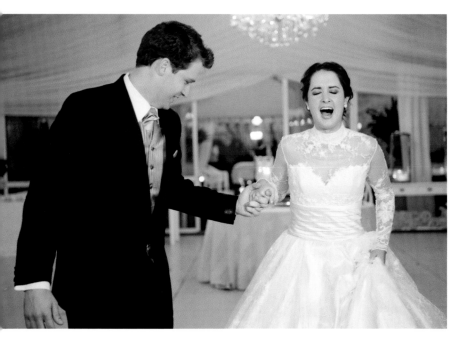

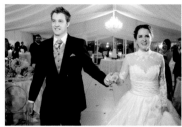

**6-3, 6-4, 6-5.** Claire and Chris arriving at the reception.

some lovely, happy moments of them walking into the reception (6-3, 6-4, 6-5).

**Appetizers.** It wasn't long before the starters were served. I often make a collage of food shots for the album, especially if it is very well presented. Here, I photographed the food using my LED lighting and my 55mm macro lens. I shot image 6-6 on ISO 1000, wide open at f/3.5 and at $^1\!/_{500}$ second.

**Speeches**. In between the starter and the main course, it was time to start the speeches for the evening. Because there was lots of white draping and fabric in the marquee, I was able to bounce the light from my Elinchrom Ranger off the ceiling, creating soft lighting on the subjects who were making the speeches. I shot these at f/4.5 to give me a little extra depth of field because people do tend to move around a bit when they are talking. When shooting, I held my focus and waited for the speaker to lift his or her head and look up (6-7, 6-8, 6-9, 6-10).

**6-6.** Food images make a nice addition to the album.

**6-7, 6-8, 6-9, 6-10.** Bounce flash helped me get clean images of each of the speakers.

Because I bounced the Ranger off the ceiling, the light falling onto the listening guests was very similar to the light falling onto the people speaking, so I used the same settings as I looked around for nice reaction shots of the bride, groom, and guests listening to the speeches (6-11, 6-12, 6-13). Again, I wanted to capture some great options for the album, so I photographed as many people as I could.

I also shoot reaction images of the bride and groom through the glasses and other décor items on the table. This gives me a nice photojournalistic look and the blurred ele-

**6-11, 6-12, 6-13.** I photographed as many people reacting to the speeches as I could. I even got a nice shot of Granddad listening, which is very special.

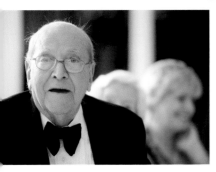

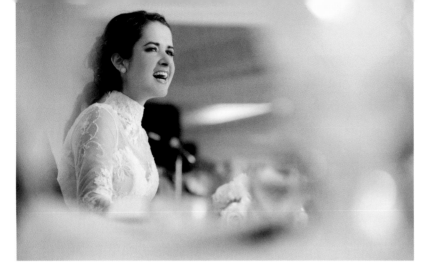

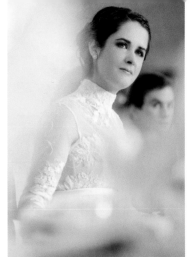

ments help draw the viewer's attention to the person listening, who is shown in sharp focus (6-14, 6-15, 6-16).

I also tried to go behind the bride and groom while the speeches were in progress, just to get a sense of what it felt like from the newlywed's perspective—for example while the bride was listening to her dad make his speech (6-17, 6-18).

It's important to get a shot of every single person who is making a speech, as well as some nice reaction shots from the people who are listening. Look to show a range of emotions. For example, Claire was crying as her dad was making his speech, so I took some emotive shots of her. I also got some fabulous reaction shots of Claire when Chris was making his speech about her.

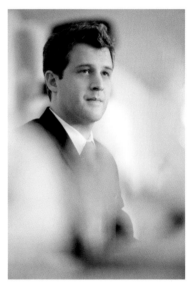

**6-14, 6-15, 6-16.** Table elements blurred in the foreground draw your eye to the sharply focused subject.

**6-17, 6-18.** These images help show the speeches from the bride's perspective.

**6-19, 6-20, 6-21.** Images of the guests mingling as they are starting to unwind.

"People are starting to unwind but they are not yet wild and out of control."

**The Guests Mingling.** After the speeches and before the main course, I walked around and captured shots of the guests mingling (6-19, 6-20, 6-21). This is the ideal time for these images; people are starting to unwind but they are not yet wild and out of control (as can be the case later in the evening). I generally photograph them chatting in small groups of about four or five. I use off-camera LED lighting for a lovely ambient look. My assistant positions the LED on a monopod, so it's not shining directly into the subjects' faces.

**The Cake.** After having taken as many group shots as I could, I shot a picture of the cake, again using LED lighting (6-22). I shot this with my 70–200 f/2.8 lens at $\frac{1}{160}$ second and ISO 2000, using the aperture priority mode.

**6-22.** The cake, photographed with LED lighting.

## 8:15PM | Dinner Is Served

Finally, it was time for dinner to be served, so I captured some mouth-watering images of the main course and the desserts. I always give these food shots to the catering suppliers. I know that the bride and groom will also appreciate them, though; in the excitement of the wedding, couples often don't have a chance to eat and can't even remember what was served or how it looked (6-23).

**6-23.** Food images are nice for the caterers and the couple.

## 8:55PM | Let the Party Begin

**Group Portraits with the Guests.** After dinner and just before the rest of the formalities, I like to get a group photograph of the groom with all his friends and the bride with all her friends (6-24, 6-25). We have already photographed the family, so this a good opportunity to get all the other important people in one picture. It also involves a bit of marketing for me; potentially, my future clients are sitting in front of the camera, so getting them involved in the wedding

"I like to get a group photograph of the groom with all his friends and the bride with all her friends."

and making sure the shots are fun, slick, and memorable, is important to me. Getting people up to pose also ensures they are out of their seats before we start the first dance—it gets the blood pumping so they can get onto the dance floor and start the party. Otherwise, people just tend to sit around after they have eaten and watch the first dance from a distance. For these group shots, I bounced the Ranger flash off the ceiling as I did when photographing the speeches. However, my subjects were now a little closer to me, so I stopped down to f/5.6, on the manual setting, and ISO 1000 at $\frac{1}{100}$ second.

"Getting people up to pose ensures they are out of their seats before we start the first dance."

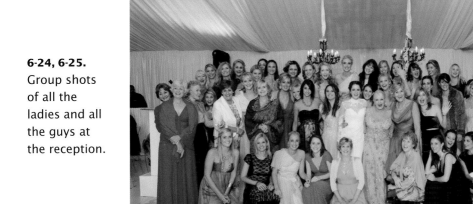

**6-24, 6-25.** Group shots of all the ladies and all the guys at the reception.

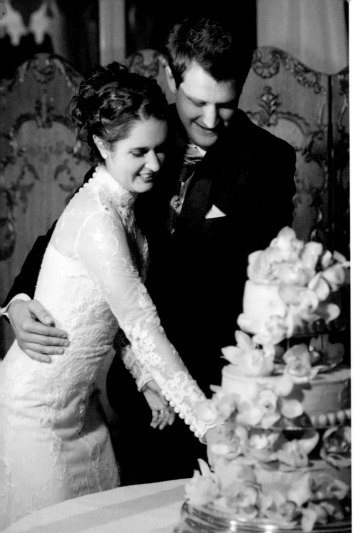

**6-26, 6-27, 6-28.** Cutting the cake.

**Cutting the Cake.** Straight after the group shot, the bride and groom cut the cake (6-26, 6-27, 6-28), then ventured onto the dance floor. Different weddings have different event orders, but I had specifically liaised with the DJ and we agreed to follow this order. I find that it works well for me. The cake cutting was lit with LED and I shot it at ISO 1250 and f/3.5 at $^1/_{80}$ second. I was in aperture priority with $-^2/_3$ stop exposure compensation, because the light was a little bright on the couple.

**The First Dance.** The time now was 9:10PM, and the couple was ready for the first dance. I never shoot the first dance with a strobe or flash; I want to capture the essence and mood of the event, which is very much about romance. I position my assistant with an LED behind the couple so that they are between my assistant and me. The assistant shines the LED toward me, creating beautiful backlighting for a nice flare around the bride and groom (6-29, 6-30, 6-31, 6-32). For the dancing images of Claire and Chris I shot at ISO 2500 and f/2.8 at $^1/_{125}$ second. These images had to be captured in manual mode, because the LED sometimes gets into the

shot. If you were in auto mode when this happened, the LED would influence the matrix reading of your camera's light metering system and result in a poor exposure.

At Chris and Claire's wedding, there was appealing ambient light in the room, so presenting these images in

**6-29, 6-30, 6-31, 6-32.** Images of the first dance, shot with LED backlighting.

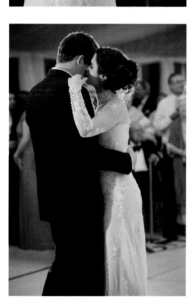

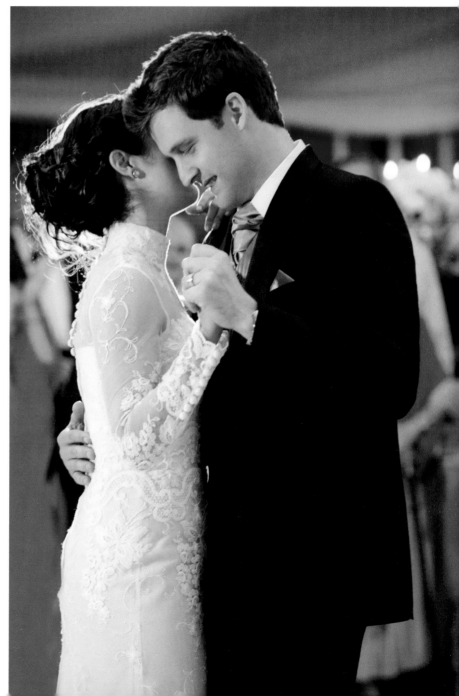

**6-33, 6-34, 6-35, 6-36.** The same images, presented in black & white.

color worked well. More often, I convert the first-dance images to black & white because it distinguishes them from the photographs of the guests dancing, which are in color. My general feeling is that the photographs of the bride and groom dancing tend to feel more personal and intimate in black & white (6-33, 6-34, 6-35, 6-36).

The first dance presents an interesting challenge because it is difficult to focus in the dark—especially when you are shooting at f/2.8. A good solution is to use your speedlight as a focus assist. As long as you disable the flash so it does not fire, you can use the invisible infrared beam the flash unit emits to make focusing in the dark unbelievably easy. With this technique, 95 percent of your

**6-37, 6-38, 6-39.** Off-camera flash produced great images of the guests dancing.

images shot in the dark will be in focus and usable.

**Dancing Guests.** When the guests start dancing, I use my TTL extension cord, the Nikon SC29 (with the autofocus assist function), and shoot away with the off-camera speedlight. I also sync this light up to a second slaved speedlight, using the Nikon Creative Lighting System. The slaved flash is on a monopod held in the background by my assistant, giving each shot a lot more dimension (6-37, 6-38, 6-39). I can add a gel to that flash for some nice color effects—blue, red, or green, depending on the ambient light

(6-40, 6-41). With this setup, dragging the shutter will allow more ambient light in and enhance the sense of movement and fun.

Once I had my safe shots, I whipped out the 10mm fisheye lens (I had been using the 24-70mm before that) to get creative.

**6-40, 6-41.** Adding a gel amped up the color.

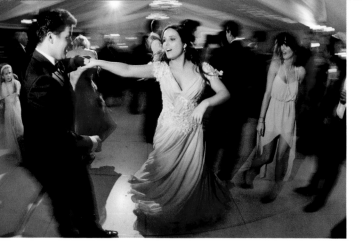

I played around with shutter speed to get some motion blur in the shots and better capture the motion, fun, and chaos on the dance floor (6-42, 6-43, 6-44).

### 11:30PM **The End of the Day**

During the rest of the evening, I continued firing shots of guests interacting and having fun. At this particular wedding, Claire and Chris had decided not to throw the bouquet or have a garter toss, so I left the wedding at 11:30PM.

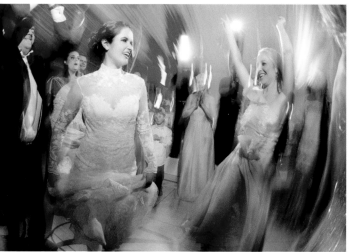

**6-42, 6-43, 6-44.** Dragging the shutter with the fisheye lens helped capture the vibrant mood on the dance floor.

# The Post-Wedding Session

Letting the clients get dressed up again and relive the magic is a good way to finish off the whole wedding experience. It's important, however, that the couple is expecting a post-wedding shoot *from the beginning.* If they're prepared for it, they will see it as a natural part of the whole process.

If you don't introduce the idea of a post-wedding shoot *before* the wedding, the couple may think that it's being scheduled to make up for images missed on the wedding day itself. This could cause the clients to lose faith in your abilities. Also, they will probably be annoyed at being asked to find time in their schedules for an "unplanned" session. That's not the kind of atmosphere that will be conducive to a great, romantic shoot.

With Claire and Chris, the post-wedding shoot was a well-planned part of their photography package. They were looking forward to the chance to produce some creative

> "We knew that the images from the shoot would fit in perfectly and greatly enhance their final album."

images—and they even had all their styling replicated from the wedding day. This all led to a feeling of excitement and romance, recapturing the emotions of their big event. We knew that the images from the shoot would fit in perfectly and greatly enhance their final album.

## Theme and Location

For Chris and Claire's post-wedding shoot, we decided to draw inspiration from two sources: Emily Brontë's novel *Wuthering Heights* and Steven Spielberg's epic film *Warhorse*. Both influences suggested very cinematic, fashion-inspired looks with loads of possibilities. We used Claire's own horse as a prop—and a very well-behaved prop he was.

To create that cinematic atmosphere, we wanted a moody and dramatic scene with brooding clouds and quite a desolate landscape. However, it was winter in Durban (on the east coast of South Africa), a time when we experience very mild temperatures and sunny, blue skies. The stormy clouds and stark atmosphere were going to need a bit of creative intervention!

## The Shoot

**Setup 1: Claire on a Rocky Slope.** I arranged to do the post-wedding shoot at 3:00PM. We chose a valley very close to Claire's home where I knew there would be quite a bit of shade at that time of day, helping me get a cold, overcast look. Chris was a bit delayed at work, so I started with some images of Claire while we waited.

I started off by using the Ranger RX with the Octa softbox fitted onto it. My assistant used a Manfrotto 680B monopod to light Claire from an elevated viewpoint. I positioned her standing on a rock which had quite an angle to it, giving us some shape to work with. I was shooting this full-length to show the entire dress. I asked Claire to pose

**7-1.** The existing scene had a blue sky.

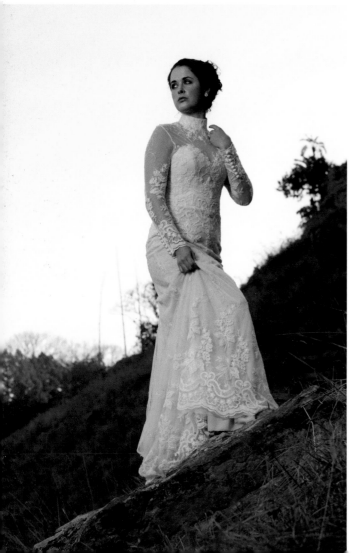

**7-2.** Getting the Octa softbox into position.

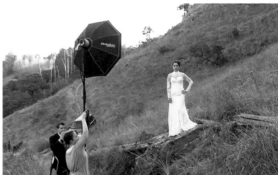

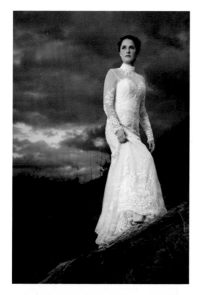

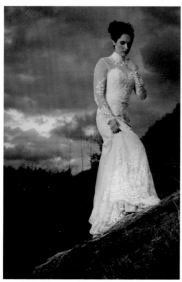

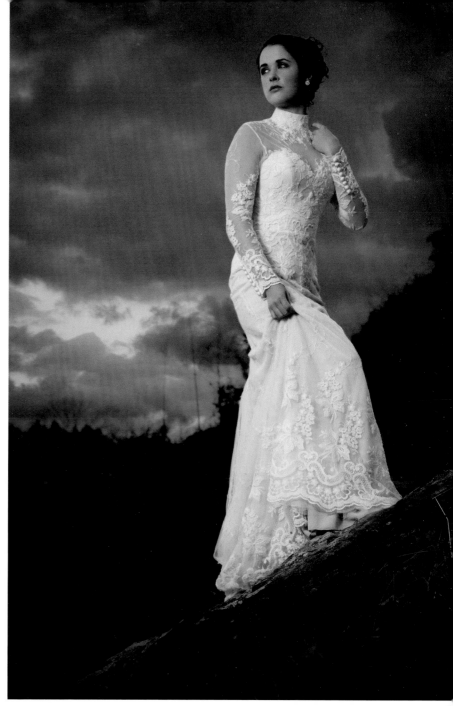

**7-3, 7-4, 7-5.** Dropping in a cloudy sky during postproduction completed the mood. Claire's posing variations gave me some nice options for the storybook.

three or four ways, just to give us some variations for the album. I shot this at $1/200$ second and f/8 at ISO 160. As you can see in the "before" image (7-1), the real background was a blue sky. Dropping in some ominous storm clouds completed the mood (7-3, 7-4, 7-5).

**Setup 2: Claire Seated.** I then shot from a different angle, sitting Claire on the rock and using the same lighting. I incorporated some dead trees in the background to give the scene a very barren feeling, emulating the Yorkshire moors of the Brontë novel. Again, a stormy sky was added in postproduction (7-7, 7-8, 7-9).

**Setup 3: Natural Light Portraits with the Horse.** Chris arrived at about 3:30PM and we began photographing them together with Claire's horse. I wanted to ensure that I didn't startle the horse, so I avoided using flash at the start of the

**7-6.** One of the seated images, as it was shot.

**7-7, 7-8, 7-9.** Postproduction yielded the desired look, a quality that wasn't feasible to shoot in this region at this time of year.

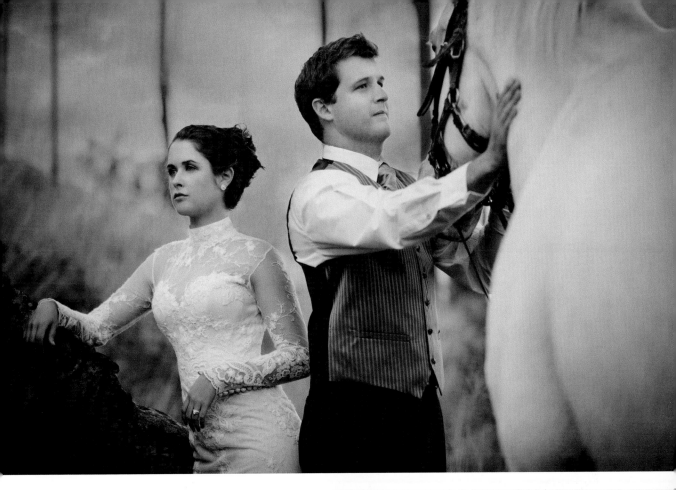

**7-10, 7-11.** I eased into working with the horse by shooting with natural light. Claire was in a pretty much stationary position while Chris interacted with the horse.

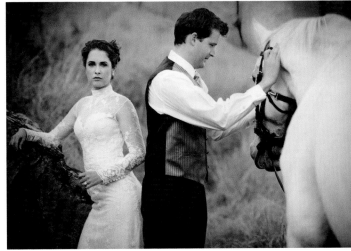

session. I had Claire stand in quite a static position and let Chris interact with the horse (7-10, 7-11). I shot at f/2 because I wanted to focus on Claire; if Chris was a little soft, I was not worried about it. I thought it was quite dark, so I set my ISO to 500, which I didn't actually need to do because my shutter speed was $1/1600$ second. So, I could have shot it at a lower ISO, but the D4's clarity is amazing, so I wasn't too worried about noise.

Shooting like this, I had to fire off a lot of shots because the horse was moving around, but in four or five minutes working on

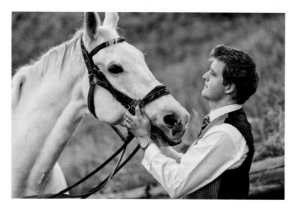

**7-12, 7-13.** Individual images of Chris with the horse.

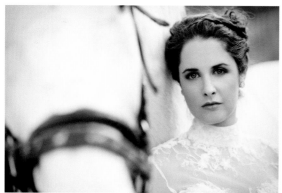

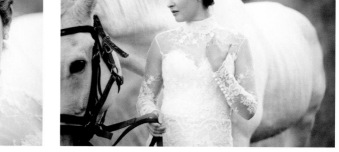

**7-14, 7-15.** Nice views of Claire and her horse.

this scene I had captured over fifty shots. I also had quite a clear picture of what shots I wanted for the album. I was looking for about four double-page spreads. I needed Claire by herself, Chris by himself, and the two of them as a couple.

With the horse already in position, I used the opportunity to get images of Chris on his own, interacting with the horse (7-12, 7-13). It took about five minutes to shoot the images I needed. Once again, I was shooting *lots* of images; with the camera set to the

Continuous High shooting mode, I was capturing 11 frames per second and got some nice options to use in the album. These were shot on aperture priority at ISO 500 and f/2. My shutter speeds ranged from $\frac{1}{1250}$ to $\frac{1}{1600}$ second. I also captured nice views of Claire with her horse (7-14, 7-15).

**Setup 4: Back to the Rocky Slope with Chris and Claire.** As the horse was moved off to another area where we were going to do our final shot with him, I resumed the use of flash for a dramatic picture of Claire,

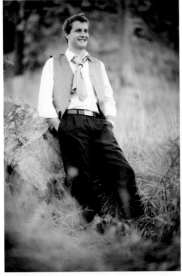

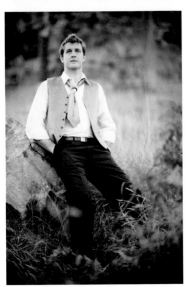

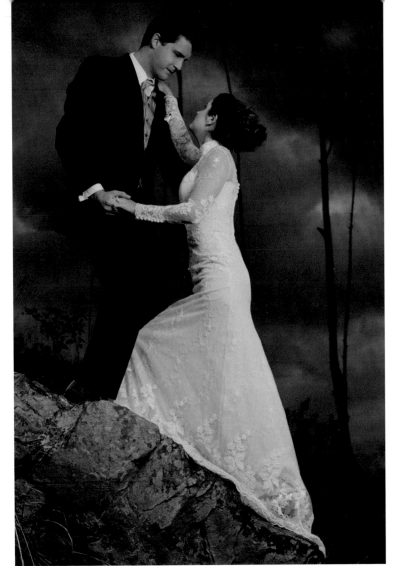

7-16 (ABOVE). Returning to the sloped rocks where we began the session, I created a dramatic image of the couple.

7-17, 7-18, 7-19 (LEFT). Relaxed images of Chris.

reaching up to Chris atop a rock. For these images, I used the same settings as I did in the earlier images of Claire in this same location. I captured a wonderful image with quite a lot of passion and romance to it (7-16).

**Setup 5: Portraits at the Cliff.** After that, we moved around the hillside to a beautiful cliff area where I photographed Chris by himself, shooting with a 85mm f/1.4 lens

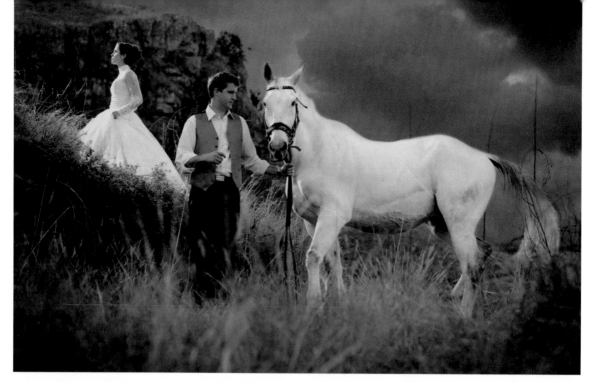

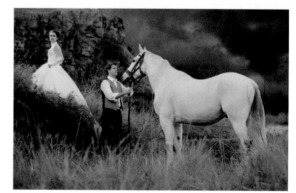

**7-20, 7-21, 7-22.** There was a lot of movement in this setup, so I captured several shots.

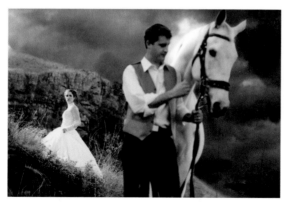

**7-23.** I had Chris walk the horse toward me for another nice look.

wide open for a very shallow depth of field. For more of a relaxed feel, I asked Chris to remove his cuff links, roll up his sleeves, and unbutton his shirt collar.

Moving on to the last image of the couple, I wanted quite a stylized shot. I envisaged Claire looking up into the sunset while Chris was almost at her feet with the horse. I had my assistant Samantha up on the hill

"A dramatic sky was added to each image in postproduction."

in front of Claire with the Ranger RX fitted with an Octa softbox for warm, soft light. My camera was set to shutter priority because I didn't want to exceed the flash sync speed. So I had it on $\frac{1}{200}$ second at ISO 160 and f/3.5. There was a lot of movement in this shot, so I shot quite a few different options (7-20, 7-21, 7-22). I finished by having Chris walk the horse toward me, capturing some great motion and beautiful images with Claire in focus and the horse and Chris falling out of focus (7-23). Again, a dramatic sky was added to each image in postproduction to create the desired mood.

Finally, I thought I would go for a nice, safe shot—just to make sure that I had some lovely images of Chris and Claire together. I had Chris go up on to the hill and embrace Claire in a very typical bridal pose with their smiling faces together

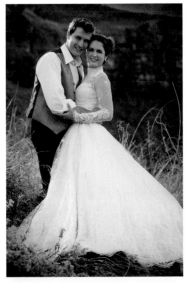

**7-24, 7-25.** We finished the couple portraits with classic looks.

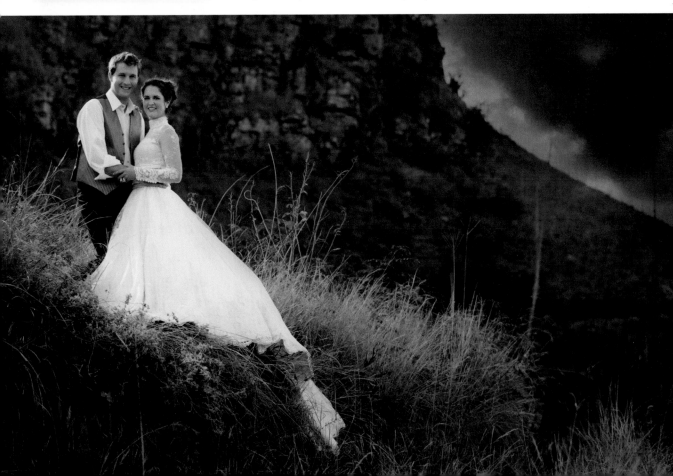

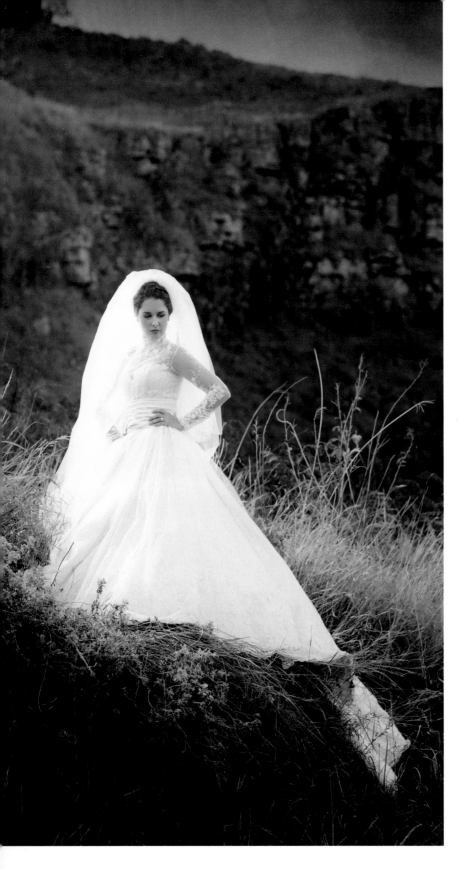

and turned toward the camera (7-24, 7-25). They were lit with flash from behind.

Just for nostalgia—and especially for Claire's mom—we shot one more bridal image with the veil in Claire's hair. For this, we used a softbox to add backlighting (7-26).

## An Hour, Start to Finish

The entire shoot, from the first image to the last image, lasted exactly one hour; I took the first image at 3:13PM and the last at 4:13PM. This meant that, technically, we could have squeezed in the session on the wedding day itself. However, Claire's dress might have gotten a little dirty, which is not ideal, and we would have kept the guests waiting an additional hour.

**7-26.** The final look was a portrait of Claire in her veil.

# The Wedding Storybook(s)

When it came to constructing the albums and storybooks that Claire and Chris were going to receive, we had quite a lot of fun. Claire had opted for my largest package, so we were able to create various albums for different people.

## Fifteen Albums

Including their album and a proof book, Chris and Claire received fifteen albums. Each book was custom-made for the recipient and designed to feature images that were particularly pertinent to that individual.

I created a customized album for Claire's parents, and one each for the groom's mother and father, who are divorced. These storybooks each had a particular bias toward that specific family, with the larger images in the book pertaining to the recipient(s) and to the closest members of their family.

> "Each bridesmaid and groomsman received a book that was designed for them."

Each bridesmaid and groomsman also received a book that was designed specifically for them. These included a note from Claire and Chris in the front, making the books all the more personalized and meaningful.

## The Couple's Main Album

For their own wedding storybook, Claire and Chris chose an exquisite Italian leather,

hand-crafted album with about three-hundred images. These were presented in a very simple but effective "storyline" layout.

> "The story begins with the bride and her bridesmaids preparing for the day."

For this system of layout, I always start off with the bride, as I believe that ladies should always come first. When you open the album (which is included at the end of this chapter), the story begins with the bride and her bridesmaids preparing for the day. The album then moves on to single portraits of the bridesmaids and a group photograph of all the bridesmaids and the bride together—

all dressed and looking perfectly beautiful. Then, I put in the images of the guys doing their activity in the morning and getting ready.

The church pictures follow, beginning with Chris waiting for his bride. From there, I have the images move more or less chronologically through the day's events, right through to the end of the evening. The one exception is the addition of the day-after photos, which followed the images from the other post-ceremony location sessions shot on the wedding day.

On the following pages, I have included the double-page spreads from the storybook that was created specifically for Chris and Claire.

**8-1.** Opening with Claire's accessories and ring.

**8-2.** Black & white images of Claire getting ready.

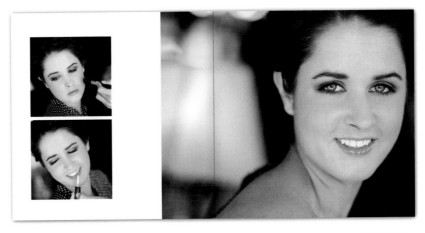

**8-3.** Claire's joyful expression carries this open spread.

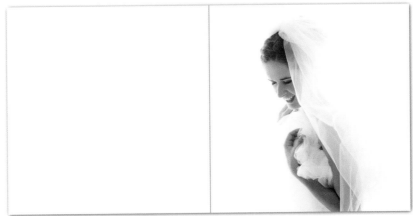

**8-4.** A different style and presentation as Claire finished getting ready.

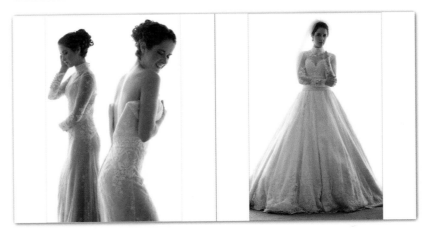

**8-5.** We stay with Claire, but another different look helps hold the viewer's interest.

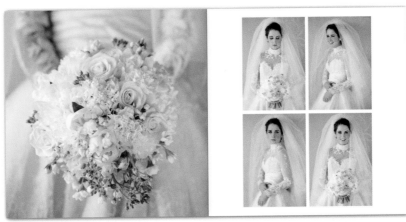

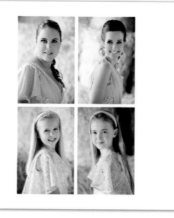

**8-6.** Now, we meet the other ladies from the bridal party—including the flower girls.

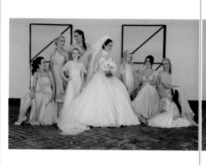
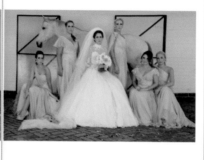

**8-7.** The bride's entire party is shown on the left. On the right-hand page, I added her horse to an image of just the adult members of the group.

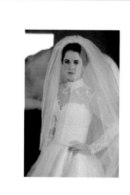

**8-8.** Additional images of Claire with her favorite horse included subtly in the background.

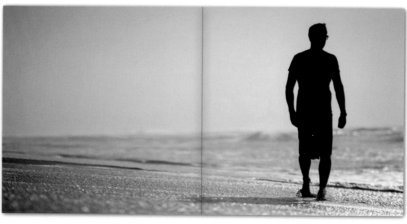

**8-9.** Chris enters the album in a tranquil beach portrait from the morning of the wedding.

**8-10.** The guys are shown in spirited candids and a powerful posed image.

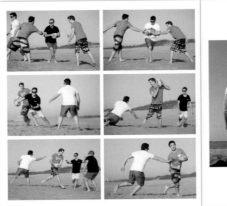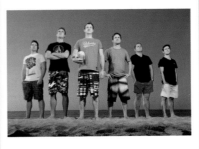

**8-11.** Portraits of Chris getting dressed for the wedding pair up with a few shots of his accessories for the day.

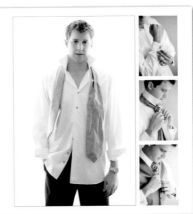

**8-12.** Classic images of the groom, in both reflective and smiling poses.

**8-13.** All cleaned up from their beach outing, the groomsmen are presented in individual portraits. A larger portrait of Chris from the same scene is perfect for the facing page.

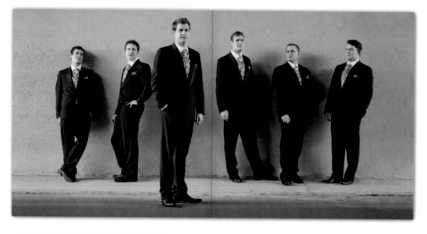

**8-13.** Chris steps to the foreground for a shot of the whole group that keeps the emphasis on him.

**8-14.** As events begin at the church, Claire is arriving in her car while Chris waits in the sanctuary.

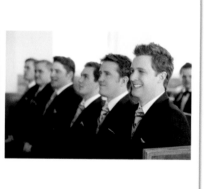

**8-15.** Claire and her dad share a laugh as they walk down the aisle.

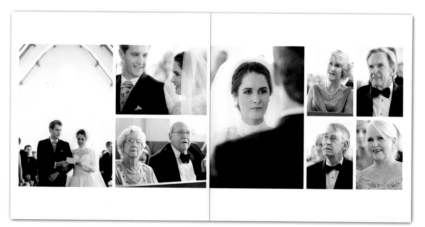

**8-16.** Moments from the ceremony—and the reactions from important onlookers, like the couple's parents and grandparents.

**8-17.** A wide view of the whole scene (and decorations) from a high angle at the back of the church.

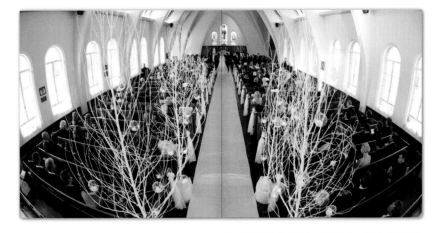

**8-18.** The vows, ring exchange, and kiss are key events.

**8-19.** Claire and Chris leave the church, pausing a moment for their first "formal" portrait as a married couple.

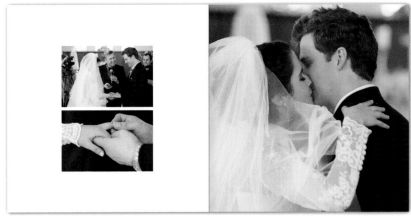

**8-20.** Black & white candids capture the congratulations. These are paired with a birds-eye shot of the scene.

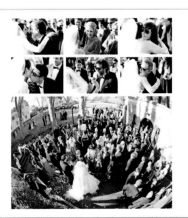

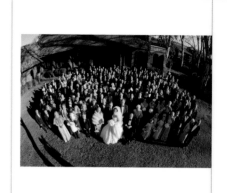

**8-21.** The whole crowd was assembled for an image at the church, then broken off into smaller portraits of the family groups.

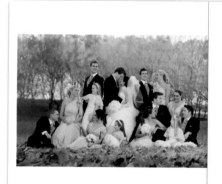

**8-22.** Portraits with their parents and other family members are important to every bride and groom—and to their families.

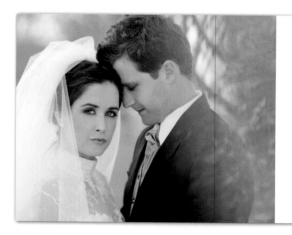

**8-23.** Moving to a new location with the whole wedding party, I created posed looks and some portraits in motion.

**8-24.** Now, the album comes back to the stars of the day with some romantic images of Chris and Claire.

**8-25.** Candid moments give us a sense of their love.

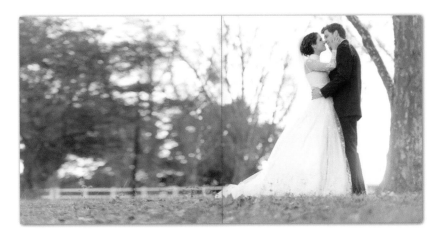

**8-26.** Closer portraits show all the details, with simple posing changes to keep the viewer engaged in the story.

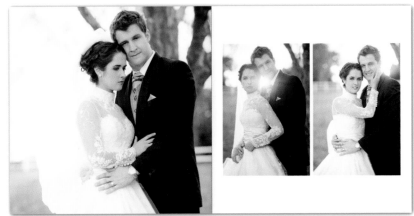

**8-27.** Another private moment captured from a distance.

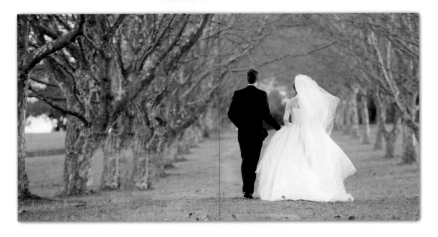

**8-28.** Remember the post-wedding session we covered in chapter 7? This gave me plenty of images to choose from when creating the album. Here, we focus on Chris—and are reminded of the wedding's equestrian theme.

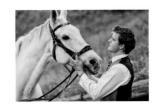
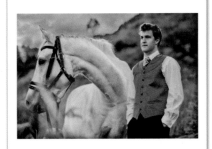

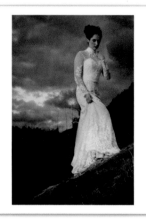
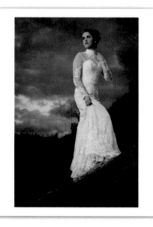

**8-29.** A dramatic look for Claire that also show-cases her gown's second look (see page 52).

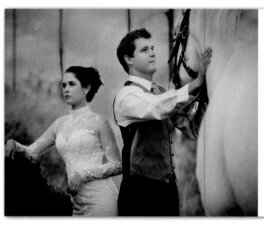

**8-30.** Claire looks on in another editorial-style pose as Chris interacts with the horse.

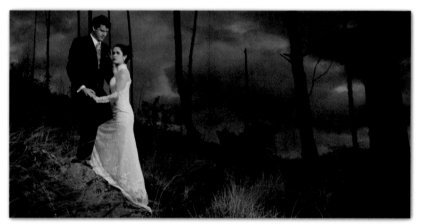

**8-31.** A dramatic look at the newlyweds.

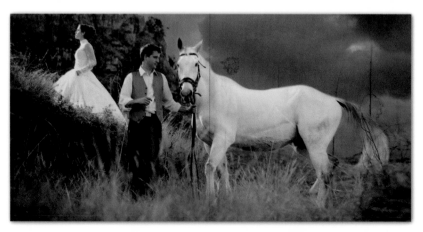

**8-32.** Our final album image from this scene brings Claire, Chris, and the horse all together.

**8-33.** Finally, it's on to the party—with detail images, the arrival of the couple, and a shot of the head table.

**8-33.** Claire reacts to the speeches and toasts.

**8-34.** The couple's first dance.

**8-35.** Images of Claire and Chris cutting loose with all their guests conclude the album on a celebratory note.

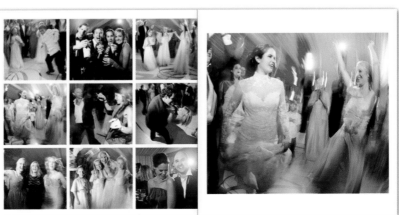

# The End of the Road

On the journey that was Chris and Claire's wedding, we have now come to the end of the road. Of course, the journey of their life together as a married couple has just begun. For my part, I'm stepping off that road—for now. However, having forged a relationship with this couple, I'm sure to cross their path many times again. Whether it's at their friends' weddings, or when they call me to shoot their maternity portraits and document the first few weeks of their newborn's life, I'll be there. The beauty of producing the perfect experience for a couple on their wedding journey is that they'll be unlikely to entrust anyone else with the task of capturing the rest of their life's most special memories.

*A NOTE FROM THE BRIDE . . .*

"I am ecstatic with the photographs Brett created—I love the way he interpreted our wedding and personalities."

# Index

### LED Lighting: PROFESSIONAL TECHNIQUES FOR DIGITAL PHOTOGRAPHERS

Kirk Tuck's comprehensive look at LED lighting reveals the ins-and-outs of the technology and shows how to put it to great use. *$34.95 list, 7.5x10, 160p, 380 color images, order no. 1958.*

### Nikon® Speedlight® Handbook

Stephanie Zettl gets down and dirty with this dynamic lighting system, showing you how to maximize your results in the studio or on location. *$34.95 list, 7.5x10, 160p, 300 color images, order no. 1959.*

### Step-by-Step Posing for Portrait Photography

Jeff Smith provides easy-to-digest, heavily illustrated posing lessons designed to speed learning and maximize success. *$34.95 list, 7.5x10, 160p, 300 color images, order no. 1960.*

### Lighting Essentials: LIGHTING FOR TEXTURE, CONTRAST, AND DIMENSION

Don Giannatti explores lighting to define shape, conceal or emphasize texture, and enhance the feeling of a third dimension. *$34.95 list, 7.5x10, 160p, 220 color images, order no. 1961.*

### Behind the Shutter

Salvatore Cincotta shares the business and marketing information you need to build a thriving wedding photography business. *$34.95 list, 7.5x10, 160p, 230 color images, index, order no. 1953.*

### Engagement Portraiture

Tracy Dorr demonstrates how to create masterful engagement portraits and build a marketing and sales approach that maximizes profits. *$34.95 list, 8.5x11, 128p, 200 color images, index, order no. 1946.*

### Wedding Photojournalism
#### THE BUSINESS OF AESTHETICS

Paul D. Van Hoy II shows you how to create strong images, implement smart business and marketing practices, and more. *$34.95 list, 8.5x11, 128p, 230 color images, index, order no. 1939.*

### 500 Poses for Photographing Brides

Michelle Perkins showcases an array of head-and-shoulders, three-quarter, full-length, and seated and standing poses. *$34.95 list, 8.5x11, 128p, 500 color images, index, order no. 1909.*

WES KRONINGER'S
### Lighting Design Techniques
#### FOR DIGITAL PHOTOGRAPHERS

Create setups that blur the lines between fashion, editorial, and classic portraits. *$34.95 list, 8.5x11, 128p, 80 color images, 60 diagrams, index, order no. 1930.*

BILL HURTER'S
### Small Flash Photography

Learn to select and place small flash units, choose proper flash settings and communication, and more. *$34.95 list, 8.5x11, 128p, 180 color photos and diagrams, index, order no. 1936.*